HIDDEN HISTORY OF ST. AUGUSTINE

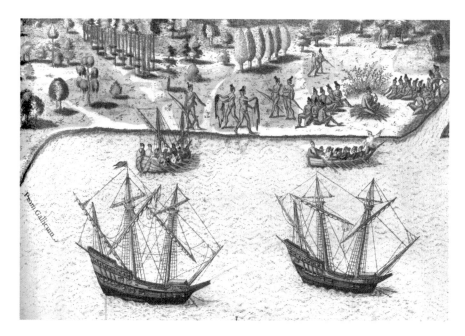

RIVER OF DOLPHINS, AKA MATANZAS RIVER—FUTURE SITE OF ST. AUGUSTINE. *French Arrival in Florida.* Jacques Le Moyne de Morgues.

HIDDEN HISTORY OF ST. AUGUSTINE

DREW SAPPINGTON

THE
History
PRESS

Published by The History Press
Charleston, SC 29403
www.historypress.net

All images courtesy of St. Augustine Historical Society unless otherwise noted.

First published 2011

Manufactured in the United States

ISBN 978.1.60949.223.6

Library of Congress Cataloging-in-Publication Data
Sappington, Drew.
Hidden history of St. Augustine / Drew Sappington.
p. cm.
Includes bibliographical references.
ISBN 978-1-60949-223-6
1. Saint Augustine (Fla.)--History--Anecdotes. 2. Saint Augustine (Fla.)--Biography--
Anecdotes. I. Title.
F319.S2S29 2011
975.9'18--dc22
2011001417

To Sharon, with love.

CONTENTS

Acknowledgements 11

Introduction. Can't Take the Story Out of History 13

1. Hernando de Soto and the Mime of Doom 15

The unsinkable greyhound, the dueling Spanish flagships and the battle of the Courteous Captains take a back seat to the mounted mime who almost sinks a fleet.

2. Four, Three, Two, One: Don't Mess With Pedro 19

The future founder of St. Augustine was a feisty lad in his youth.

3. If You Can Keep Your Head, When All About You Are Losing Theirs… 23

Momma was wrong. Musicians have more security than other professionals.

4. Payback 30

Freedom of religion, yes. But not freedom to be Spanish.

5. A Funny Thing Happened on the Way to the Office: Governor Ybarra Loses His Shirt 35

Boarded by buccaneers, adrift in an open boat, driven barefoot across a jungle. And that's before he's on the clock.

6. The Pirates of Paynes Prairie and the Accountants of the Caribbean 39

Native Americans battle pirates to rescue cowboys. Then it gets weird.

Contents

7. Was Sotolongo Really So Wrongo? 43

OK, maybe the guy had a few hang-ups. But he could have been right about the buccaneers.

8. Poker 47

The first test of the Castillo de San Marcos; a governor's foul mouth doesn't help matters.

9. Twist of Fate 52

Lively pirate helps to build fort after his execution.

10. The Christmas Siege of 1702 55

I saw two ships come sailing in: why there were bulls a-bellowing and lords a-leaping on Christmas Eve.

11. The Remarkable Ear of Robert Jenkins 60

An aural history of a war.

12. Lucky Pierre 63

A French draftee in the British army changes the course of a battle—and is subsequently framed by Governor Oglethorpe.

13. Extreme Bird-Watching and the Fallibility of Risk-Management Specialists 68

William Bartram demonstrates that botany is a more macho profession than you may have thought.

14. Governor Quesada's Affliction 71

Sure, Menendez and Zuniga fought against enemy armies. But they didn't have to deal with Jorge Biassou.

15. Ralph Waldo Emerson, Martin Luther King Jr. and the Barking Methodists 75

Them old-time Methodists didn't have much couth, but they did have something.

16. A Dream of Pyramids 79

What do Egyptian monuments have to do with infantrymen marching from Tampa to Ocala?

17. Hogtown Changes Its Name 83

The road to destiny is forked by choices, but for some, all paths lead to glory.

18. Gotta Get a Receipt 86

Before Confederates can take over the Castillo, they have to meet certain conditions.

19. The Year Without Tourists 89

Be careful what you wish for.

20. John, Roseda and Polly: A Cracker Family 94

The experts said to institutionalize her, but the cracker family believed in taking care of its own.

21. The Picture 97

The world's not what it used to be. But then it never was.

22. Truck Farmer 99

The police keep a black man hostage during a shakedown of a white produce seller.

23. This Little Light of Mine: Mattress Man in the Signal Corps 102

A young man steps out of his father's shadow.

24. Uncle Brother 105

He just couldn't live down to his convictions.

25. Waiting for Jingle Bells 108

Why Santa Claus was drinking in the cemetery on a cold Christmas Eve.

26. The Ferocious Fleas of Marjorie Kinnan Rawlings 113

That tricky redneck/white trash distinction is elucidated in a literary context.

27. Jamestown and the Ancient City 118

St. Augustine tries to bump off the English upstart. No hard feelings.

28. When Crackers Met Spaniards: Bloody Marsh Reenactment 121

Deciding whom to root for in a fixed fight.

Appendix. It Was Along 'Bout Then: Historical Background of Stories 125

Suggested Readings 139

About the Author 143

Acknowledgements

Thanks to the city of St. Augustine for its inexhaustible supply of great stories and to the Historical Society of St. Augustine for making those tales accessible. Special thanks to one of their members, Charles Tingley, who spent considerable time helping me to track down suitable images. I am very grateful to my writing group—including Eve Bates, Kathy Delaney, Ray Feliciano, C.J. Godwin, Jim James, Mel Minson, Arliss Ryan, Claire Sloane, Marie Vernon and Ralph Voss—for their encouragement and constructive feedback. I also owe a great debt to the Tale Tellers of St. Augustine for their guidance in crafting a tellable tale. Finally, I would like to thank Jessica Berzon and the staff at The History Press for their help and patience. Please don't blame any of these folks for my screw-ups.

INTRODUCTION
Can't Take the Story Out of History

S t. Augustine was founded in the year 1565. The Knights of Malta had just defeated the Turks, and Michelangelo had died the year before. Shakespeare was one year old—it would be a while before anyone got to watch *Romeo and Juliet*. Galileo was also one year old, and Francis Bacon just two—most of the "Scientific Revolution" wouldn't occur for decades. Twenty-three years would pass before the Spanish Armada set sail—England and Spain were more worried about France than each other. The Jamestown settlers and those Johnny-come-lately Pilgrims wouldn't hit shore until the 1600s. St. Augustinians are proud of their spectacular fort, the *Castillo de San Marcos*. But the city was old, at least by American standards, by the time that seventeenth-century structure was built.

The year 1565. Closer to the Middle Ages than to the American Revolution, it was a time when swords and armor were still practical tools of war.

Four hundred and fifty years have gone by since that founding. And that means four hundred and fifty years of stories. History is high-brow, lofty in vision, populated by men of marble and women of ivory. Story is often low-brow, the thong beneath the hoop skirt or the valentine boxers under the velvet britches, filled with people who are scared, selfish, rude, funny and definitely full of life. We need history's big picture. But we won't understand it unless we know its stories.

Stories of Spanish dons—because Florida belonged to Spain for as long as it has belonged to the United States. Stories of buccaneers—because St. Augustine's first hundred years were one long death match against pirates.

Stories of Florida crackers—because that Spanish colony became a southern town, and even recent events like the Civil War can be fascinating.

From St. Augustine's four and a half centuries come the most astonishing tales:

- a mounted mime menaces Hernando de Soto;
- a single boat attacks a pirate fleet;
- a flute player survives the massacre of an army;
- Native Americans attack pirates to rescue cowboys and a Spanish don, while rampaging accountants loot a city;
- the first assault on the Castillo de San Marcos is countered by a gigantic bluff;
- there were lords a'leaping and bulls a'bellowing during the Christmas siege of 1702;
- a remarkable ear—made of rabbit skin—starts a war;
- the highest-ranking officer in St. Augustine is a black general—a really obnoxious one;
- Ralph Waldo Emerson encounters slavery—and barking Methodists;
- one bureaucratic Union sergeant defies the Confederate army at the Castillo;
- St. Augustine police demand that a truck farmer leave a hostage;
- a cloud of ferocious fleas threatens author Marjorie Kinnan Rawlings's home.

Always serious but seldom solemn, this book tells St. Augustine's history through these outrageous tales. Admittedly, many of the stories are unbelievable; the only defense I can offer is that they are true. An appendix gives the historical context of the stories.

Storytellers are invited to tell or adapt the tales themselves; teachers are invited to use them to enliven their lessons; everyone is invited to enjoy them.

Have fun.

CHAPTER 1

HERNANDO DE SOTO AND THE MIME OF DOOM

You hear a lot about the deeds of the conquistadors and all the derring-do that they did. Yet before that daring could be done, the conquistadors had to get to where they intended to conquist. That meant a sea voyage. And those commutes could be pretty interesting in themselves. Take, for instance, the journey of Hernando de Soto from Spain to Cuba, on the way to his disastrous exploration of Florida.

Now there are any number of stories we could pick from this voyage. There is the story of how de Soto's flagship mistook another Spanish flagship for a pirate vessel in the dark and exchanged broadsides until the matter could be clarified. We could talk about the Unsinkable Greyhound, the dog found swimming in the middle of the Atlantic with no ship in sight. We could talk about the young ladies who were on board de Soto's ship, bound for Cuba, and of the young men trying to impress them with their gallantry.

But I believe my favorite tale from that voyage is the Mystery of the Mounted Mime, which itself hinges upon still another story, the Battle of the Courteous Captains.

The mime story began when the voyage was almost ended, outside the harbor of Santiago de Cuba. As the armada started to enter the harbor, with de Soto's flagship in the lead, a horseman appeared on the shore. He galloped up as close to the water's edge as he could and began to wave them away, signaling the ship to head to port. Which is sailor talk for "Hang left."

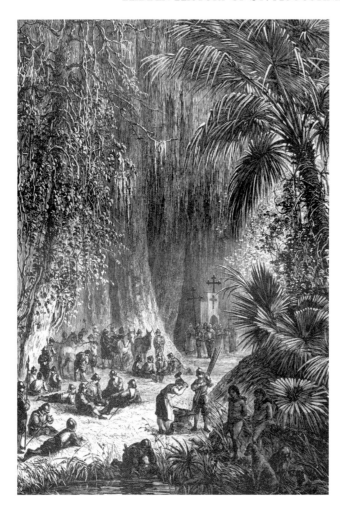

IN THE DAYS ERE HOLIDAY INN. *Bivouac of de Soto's Expedition in Florida*. In William A. Crafts, *Pioneers in The Settlement of America*, vol. 1. Boston: Samuel Walker and Company, 1896, 13.

It seemed kind of important to the fellow, and no one on board knew anything about the harbor, so what the heck. They steered port. And then suddenly the horseman clapped his hands to his head. He started yelling, although no one could make out the words. He dismounted and ran to the right. He signaled frantically with his arms and cloak.

Two syllables?

Sounds like?

They finally heard him screaming, "Return to the other side, or all is lost. Starboard! Starboard!" Which is seadog for "Better catch a right."

Once they figured out what he wanted, and got over the fact that he was giving contradictory advice, and remembered which way was "starboard,"

they desperately steered to the right. And whanged off an undersea rock. They had hit the obstacle at an angle; if they had kept steering port they would have struck it head-on and been sunk, probably along with the entire fleet that was following the flagship.

As it was, the ship had hit pretty hard. Had they done a *Titanic*—split themselves open, so that they were on their way down? They cranked up the bilge pumps, and liquid came out. There must be a hole in the side, which meant they were doomed. The ship's officers lowered a skiff and tried to get the female passengers into the lifeboat. Whereupon a number of those young men, who had spent the entire voyage trying to impress the ladies, decided that they had played the chivalry game long enough. They pushed ahead of the women and grabbed the lifeboat seats for themselves.

Everybody tried to get de Soto into that boat, but he was not a man to panic easily. He wasn't about to abandon his ship until he had inspected the damage firsthand. And when he went below deck, he found a bunch of broken jars. The liquid the bilge pumps were bringing up wasn't sea water, but wine—admittedly a tragedy, but not the end of the vessel. The sailors could get back to sailing, and the young men could get on with trying to explain their seat-grabbing behavior to the women they had been trying to impress.

"Just kidding."

"I wanted to test the boat for you."

But this still left the mystery of the mounted mime. So once the armada had anchored, de Soto summoned the town council and the mysterious horseman. The eminent conquistador had a few comments and questions for the locals.

Well, of course de Soto wanted to give credit where credit was due. He was grateful for that last minute heads-up about the rock. And that was some pretty good pantomiming the horseman had done toward the end, showed some fast thinking. It saved them from smashing against that underwater boulder.

Nevertheless, there was one minor detail that troubled de Soto. The fleet wouldn't have been anywhere near that rock, wouldn't have been in deadly danger in the first place, if the horseman hadn't originally directed them toward the lethal obstacle. So, just out of idle curiosity, and before we draw and quarter him, whasup with that?

"You're gonna laugh—"

It turned out that, a week or so before de Soto landed, a French pirate and a Spanish ship had fought a lengthy battle in the harbor. A battle that lasted

four days, with the captains fighting while the sun was up and socializing with each other in the evenings.

"How 'bout them Dutch?"

"Wife and kiddies doing okay?"

On the last day of battle, the Spaniard finally got the upper hand and chased the Frenchman into the open sea. So when the townspeople saw de Soto's armada, they figured it was the Frenchman come back with reinforcements to take the town. That's why they sent the horseman to trick the fleet onto the rocks. De Soto had himself been mistaken for a buccaneer.

But—and this, the horseman stressed, is the important part—as soon as he realized that the ships were Spanish, he did everything he could to undo the damage he had tried to do. And he certainly hoped that de Soto was going to have a good sense of humor about the whole thing.

De Soto weighed the pros and cons, and it was a difficult call. He didn't like people trying to kill him. He did have a temper—he'd been prepared to hang the commander of that other Spanish flagship, so he was certainly ready to perpetrate awful things upon the horseman.

What to do? What to do? But in the end, de Soto let it go and allowed the horseman to live—perhaps because of that ancient saying:

"A mime is a terrible thing to waste."

FOUR, THREE, TWO, ONE

Don't Mess With Pedro

Around 1540, near the coast of Spain, you could have seen:
Four pirate ships, sailing fast;
Three merchantmen, sailing slow;
Two coast guard boats sailing for home, and
One boat that stayed.

The French pirate ships were large, one galleon and three galleys, packed with cannons and troops. Think of them as powerful birds of prey, eagles and falcons. The Spanish coast guard boats were small, all three together carrying fewer men than one pirate galley; think of them as sparrow hawks. The Spanish merchantmen were cargo ships, one carrying a young bride on her way to her wedding. Think of them as sitting ducks.

Now the primary duty of the coast guard boats was to search for pirates. And they had found them. The boats watched as the corsairs captured the merchant ship with the bridal party. They had caught the bad guys red-handed. But there can be too much of a good thing. One small pirate craft was prey. Two small craft or one ship was a battle. A pirate fleet was above and beyond the call of duty. It was trouble. To attack such ships would likely raise your insurance rates and had all of the earmarks of a poor retirement plan.

Nevertheless, the young man commanding one of the coast guard boats called for the other two to join him in a rescue of the merchantman. The commanders of the other two boats called for a committee to study the situation back home in port and sailed away. With only one boat, the young man's hands were tied, so he took the only logical course of action.

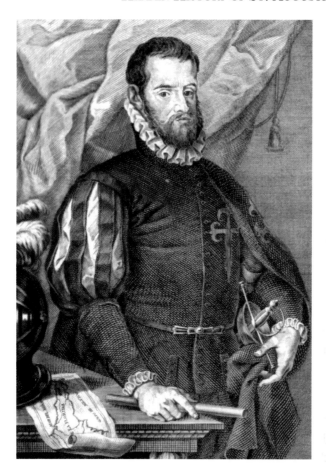

PEDRO, IN A GOOD
MOOD. *Pedro Menéndez
de Avilés.* Eighteenth-
century engraving from
a Titian portrait of Don
Pedro.

He attacked. He sailed right over to the four pirate ships while his crew contemplated the chances of a transfer. Now I do not claim to be a naval historian, but it is my considered opinion that it was not the custom at that time for single boats to assault fleets.

It may be, of course, that he hoped to sneak up on the pirates. But if that was his plan, he undermined it by his next move. He got all his banners flying. He got his fifes and drums playing. Cranked them up full blast, kind of like a sixteenth-century boombox, something to annoy his French neighbors. Music to rumble by.

Still, perhaps he hoped to be mistaken for a seagoing minstrel show. But if that was his plan, then his first words to the pirates would have cast doubt upon the disguise. Because he demanded their surrender. He said that if they did not turn loose their prey at once he would hang them all. Again, I

wish to stress my lack of credentials in the area of sixteenth-century nautical warfare. But it is my belief that such an action was atypical.

Certainly, the pirates were strangely unmoved by his threat. Not only were they reluctant to turn themselves over to Spanish justice, but they also did not wish to give up the merchantman. Worse, they eyed the coast guard boat itself with a certain air of covetousness. Two of the galleys moved to seize the little boat. The little boat moved to put some seas between itself and the pirates. In the light of the changed circumstances, the commander of the boat weighed the existing options and evaluated their strategic merits. Then he ran like cheap ink in a Florida rainstorm. So, in review, we now have:

> *Four French pirate ships altogether, who had been chasing*
> *Three Spanish merchantmen, then you had*
> *Two of the corsair galleys in pursuit of*
> *One small coast guard boat.*

The spectators on the other pirate ships and the captured merchantman watched the race from a distance, probably placing bets on the outcome. In the words of the old chronicle, "The first pirate vessel sailed faster than the second, but the boat sailed faster than either." The three craft were getting strung out, forming a kind of parade. It looked like the coast guard boat was going to take first place, and get safely away.

But the little boat didn't want to get away.

It abruptly doubled back and slammed into the lead pirate. The Spanish boarded the larger craft and captured it. And turned it around. Then both vessels slammed into the second pirate ship, and captured it. And turned it around. Now the Spanish had their own fleet, and they were going after the rest of the pirates. That sparrow hawk was getting ready to kick some eagle butt. And so you might have had:

> *Four pirate ships to start with, but by now there were*
> *Three vessels under Spanish command sailing towards the*
> *Two remaining pirate ships still holding that*
> *One merchantman.*

However, the remaining pirates were reassessing the situation. Hanging no longer appeared to be as comfortably remote a prospect as before, and they recalculated the cost-benefit analysis of this operation. France now seemed to offer better career opportunities than the waters off the coast of

Spain. And so those pirates who still had their own ships set sail for home. The merchantman and the bridal party were saved.

So, one final time, there were originally:

Four French pirates, pursuing
Three merchant vessels, then
Two galleys took off in pursuit of
Just one coast guard boat.

But. I've left out something important. That one boat was commanded by Pedro Menendez, who was to acquire a reputation as one of the best seamen of the age. He's the guy who later founded St. Augustine, Florida, 450 years ago.

CHAPTER 3

If You Can Keep Your Head, When All About You Are Losing Theirs...

It was a long time ago, before the Grateful Dead were seriously ill. Hootie hadn't met a blowfish, and the Nine Inch Nails weren't even carpet tacks yet. There were no garage bands, because the year was 1565 and garages hadn't been invented yet.

He was just another kid with dreams of hitting the big time in showbiz. Probably had him an earring, mighta had hopes of getting a tattoo. Took up the fife, which was a pretty cool instrument in the days before you could plug anything in; acoustic was where it was at in the sixteenth century. He used to get down with "The March of the Prince of Orange" and other foot-stompers of the day.

I don't know why he became a musician. He might have been into the music itself, or he might have hoped he could impress the chicks. But he must have been pretty good, because he got a gig at an early age. And not just any gig—one on a cruise ship. Not only do you get to travel, but they have to feed you as well, so you get to keep a lot of your pay. And your audience isn't going to walk out on you and go to the club up the street.

Still, there was a downside. This cruise was on a French warship, and one of the duties was playing music as the ship went into battle. That meant you had to worry more about stuff like getting shot than about bad reviews. Also, in this case, it meant going to the end of the earth. The wrong end—to the Florida wilderness, to a little fort set in the jungle on the banks of the River of May (which we call the St. Johns). Fort Caroline wasn't one of your better resorts. It was a place where people were starving

GETTING DOWN IN THE ACOUSTIC AGE. Three musicians. *Historia Orgáanica de las Armas de Infanteria y Calalleria Españolas.* Toma II. El Conde Clonard. Madrid 1854.

and agitating to go back to France. A place where a Spanish fleet was expected to attack in the near future.

Our musician might not have known it, but he was a participant in a race. His ship was part of a French fleet commanded by a famous seaman called Jean Ribault. The job of the expedition was to rescue Fort Caroline and to keep the Spanish away from that part of the world. Heading for the same destination was a Spanish fleet, commanded by a man named Pedro Menendez. Its job was to destroy the fort before it could be reinforced and then get rid of any Frenchmen on what they figured was Spanish turf. So north Florida was set for a throwdown. Possibly not the best venue for a woodwind player.

But at least the French won the race. They reached the River of May before the Spanish arrived, and they had time to unload troops and supplies. The fort had plenty of soldiers now, enough food to eat for a long time, ammunition—and musicians. The talk of heading back to France died down.

But while our fife player was waiting his turn to go ashore, the lookout sighted five sails in the distance—two moderate-size ships and three smaller craft. It was dusk by the time the vessels got close to the French fleet, and it

LIGHTNING ROD. Called Fort Carolina by the French, it was attacked by the Spanish. Later called San Mateo by the Spanish, it was attacked by the French. Jacques Le Moyne de Morgues.

was hard to tell who the newcomers were. One of the French galleons fired some warning shots, but the strangers kept coming. They didn't seem to take offense at the shots, though, because they didn't fire back. Probably a good sign. Instead, the mystery ships anchored between Ribault's fleet and the shore. Anchoring was good. Not shooting back was good. These guys were probably okay. But they still hadn't communicated with anyone.

The wind was coming from the shore, and during the night the strangers' ships drifted closer and closer to the French vessels. Finally, when the ships got close enough, one of the newcomers hailed the musician's ship.

"Where do you come from?"

Kinda late for the guy to be asking, after he's already anchored.

"From France."

"Why are you here? What religion are you?"

They back-and-forthed it for a while, with the Frenchmen answering the stranger's questions courteously. They never did retort, "What's it to you?"

But eventually someone asked the guy, "Who are you?" You know, show a little interest in the new fellow, make him feel at home. But he turned out to have trouble with small talk.

"I am Pedro Menendez de Aviles, general of this armada for the king of Spain. I have come to hang all the heretics I can find here, and I will carry out my orders at dawn."

Now this produced one of those socially awkward moments of silence. And in all honesty, when the French finally replied, their comments concerning Menendez and the king of Spain bordered on rudeness. At some point, one of the crewmen raised the question of why they should wait until dawn if the Spanish were so eager to fight. This was undoubtedly meant as a rhetorical question, but Pedro was never good at those. He ordered the anchor to be hauled up right away. The Spanish leader was ready to get it on now.

At this point, the French began to reappraise the situation. In the first place, most of their troops had already been sent ashore, so they really didn't have enough men on board to fight. And in the second place, that Menendez guy was seriously whacked out. The French cut their cables and took off in the night. This was the first time that our musician saw the Spanish leader, but it wasn't the last.

The French ships, having unloaded their heavy supplies, easily outran the Spanish in the dark. The next day, on their way back to Fort Caroline, they noticed that the dons had landed at a small harbor a few miles south of the River of May and were fortifying a Native American village. The sailors reported the existence of the Spanish base to Ribault, who may have been a little whacked out himself. Instantly he ordered the troops back onto the ships and took off toward the enemy. This continent wasn't big enough for both of them.

Ribault caught a break because the big Spanish ships were nowhere in sight; they had been sent back to Cuba. But, even better, a small boat loaded with supplies was trapped outside the harbor, unable to get over a sandbar at low tide. And, best of all, in that boat sat Pedro Menendez himself, looking for all the world like a present left for Ribault to pick up. The French admiral sailed closer and closer. Menendez looked downcast. The musician tried to select an appropriate tune for the occasion. But then the wind began to blow and stirred up the sea. The waves carried the boat over the sandbar, and so the Spanish leader escaped at the last minute.

That meant the French were going to have to do this the hard way: land troops and march on the Spanish fortification. Except that the wind picked up even more. And more. Nobody was going to land in this mess. The wind

began to shriek and howl until it was clear that nobody was going to stay anchored outside the bar, either. That was some serious weather building, probably what we would call a hurricane today. The French had to run south with the storm, battling vertical seas, struggling to keep their sails from being shredded, hoping to simply stay afloat. Hoping in vain.

The next time the musician saw Menendez, he was fixing breakfast—the Spanish leader, not the musician. And technically, Menendez wasn't personally fixing breakfast; he had just ordered his soldiers to fix breakfast. The point was that: a) there were a bunch of Spanish soldiers across the river from where the French had spent the night, b) they didn't seem to be overly concerned with the French troops and c) they were eating.

The French fleet had suffered the fate of the USS *Minnow* from *Gilligan's Island*—they were shipwrecked. The survivors had spent days hiking up the beach, trying to get back to Fort Caroline. Worrying a lot about what or who was in that jungle beside the beach. Worrying a lot about where they were going to find food. They marched until they were stopped by a kind of river and then spent the night. And the next morning, they could smell breakfast cooking. On the wrong side of the inlet.

When they arranged a talk with the Spanish, Menendez made them a proposition. They could do what they wanted, of course. If they wanted to go back the way they came, they were welcome to do so, keeping in mind that Miami wouldn't be built for another three hundred years. He would then do what he wanted about pursuing them. On the other hand, if they wanted to surrender, he would feed them. But once they surrendered they would be at his mercy, and he could do what he wanted with them. The one thing he couldn't do, though, was to take them back to their friends at Fort Caroline.

Because he had marched north during that terrible storm and captured their fort. While they were lollygagging around being shipwrecked, he was busy killing their friends. If they didn't believe him…well, he happened to have a few trophies of war from the fort that they were welcome to examine, and even a couple of prisoners they could talk to. But then they had to make their choice—the jungle, or his mercy.

There were wild beasts in those jungles: alligators and panthers and who knew what else. There were Native Americans who already didn't much like Europeans. There were rumors of cannibals. No hope of rescue, either. The French fleet was supposed to be the rescue team, and it had been shipwrecked. Ribault, our musician and most of the other Frenchmen chose to take their chances with Menendez instead of with the Florida wilderness. He was civilized, European. He would treat them okay. Right?

The Spanish rowed the French across the water ten at a time, offered them breakfast and then tied up their hands with the fuses used for matchlock muskets. Once the captives had been secured, they were marched behind the sand dunes, where they could see two things. First, the Spanish were not very numerous; the French army had the manpower advantage. But by then, the prisoners could also see something else—the bodies of their comrades who had been marched behind those dunes earlier.

There were dead people lying all over that sand. And they had not died of natural causes. Our fife player, bound and helpless, was beginning to understand the implications of all this.

A couple of days earlier, fifty Spaniards had captured and killed two hundred Frenchmen, ten at a time. And now it was the turn of Ribault. And the fife player. And the rest of the French who had decided to surrender. They had been taken across the river, just like that earlier group, and they were standing around with their hands tied behind them, staring at the previous victims and waiting for what came next. It was frankly difficult not to put a discouraging interpretation on the whole situation.

But, just then, someone must have noticed our musician's instrument and asked, "Oh, do you play?"

There were any number of professions represented among the French on the beach. Most of the men were soldiers or sailors, of course, with many specialties among them. There were artillerymen, grenadiers, navigators, people who knew something of the art of fortification. Some had civilian professions as well, making them doubly valuable in a wilderness area. There were blacksmiths and tailors and precious metal workers. There were some noblemen, which was usually a good line of work. There was Ribault's position, as commander of the whole operation.

But on that day, the very best skill to have was the ability to play an instrument. Because Menendez gave orders to spare the musicians. Entertainment was hard to come by in a frontier town in the days before cable, and he wasn't going to waste a valuable resource. Now showbiz people do not have a reputation for being the most stable of professionals. There are those who say that musicians are flighty and irresponsible. But, among the Protestants waiting on the banks of a river that would soon be called *Matanzas*, the Place of Slaughters, only the performers kept their heads.

Our fife player was taken with the other musicians to the new Spanish settlement, which was called St. Augustine. He had a long run, playing at the Mill or the White Lion, or whatever they called the taverns back then. He had to be one of the hottest acts in town. He saw the town grow from

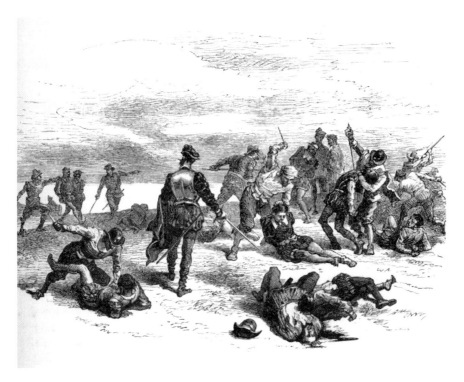

MATANZAS: HOW THE "RIVER OF DOLPHINS" BECAME THE "RIVER OF SLAUGHTER." *Massacre of Ribault*. In William C. Bryant and Sidney H. Gay, *Bryant's Popular History of the United States*, vol. 1. New York: C. Scribner's Sons, 1881–83, 211.

a collection of primitive Native American thatched huts to a group of primitive Spanish-built thatched huts. He witnessed famine and plague and attacks by various anti-Spanish groups. But one of his most important gigs was still to come.

In the year 1586, St. Augustine could finally afford to build a watchtower. And the buccaneer Francis Drake, who had no idea there was a town in these parts, saw that tower. He came to investigate with a bunch of ships and two thousand men—which turned out to be a misfortune for the new settlement.

The Spanish had built a wooden stockade, which fired on the pirates. Drake's men settled down for a fight. But that evening, the pirates heard a familiar tune—"The March of the Prince of Orange." A Protestant tune. A lone fife player came out of the stockade to tell them that the Spanish had abandoned the place. Our musician was finally going home. After twenty-one years of playing the boondocks, he was going to get a shot at Paris.

CHAPTER 4
PAYBACK

D ominique de Gourgues wasn't a big fan of the Spanish Empire. It would be less than accurate to say that he admired Spain or wished its people well. Of course he was French, and a lot of his countrymen shared similar anti-Spanish sentiments in the mid-1500s, but his enmity went beyond the national norm. Chalk it up to a labor dispute—when he was a young man, the Spanish had captured him and put him to work as a galley slave under less than ideal conditions.

His time as an involuntary provider of propulsion was eventful. The ship he was on was later captured by the Turks and then by the Knights of Malta. In those days, you could get extensive international experience while staying below decks on the same vessel. The knights freed him, and he went on to build a distinguished nautical career, commanding ships and even fleets.

But he never forgot the time he spent chained to a Spanish oar and the way he'd been treated. He never forgot how terrible it had been to be a slave. And if he was not the type to forget, still less was he the type to forgive. He carried a grudge, and he wanted to get back at those people who were so cruel as to enslave another human being. Sometimes justice calls for vengeance.

So when he heard about a massacre off the coast of far-off Florida, at a place called Matanzas, de Gourgues was not predisposed to give the don-ish perpetrators the benefit of the doubt. Neither were a lot of other Frenchmen, and the slaughter was controversial even in Spain.

The story is complicated, but here's the part that everybody agrees on. Pedro Menendez, the founder of St. Augustine, obtained the surrender of

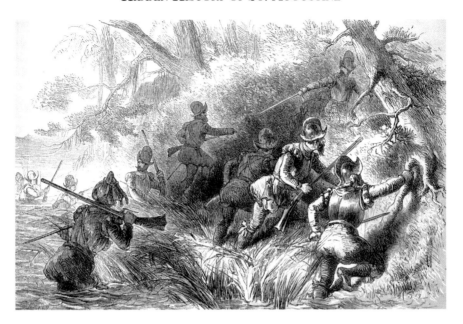

WHAT GOES AROUND. *Frenchmen Proceeding to Attack the Spanish Fort on the St. Johns.* In Benson J. Lossing, *Our Country.* New York: Henry J. Johnson, 1878, 132.

a shipwrecked French army at Matanzas inlet, disarmed the soldiers—and then executed them ten at a time. Menendez's defenders argue that he had no choice, because a) he didn't have enough provisions to feed both the prisoners and his own men; and b) the French greatly outnumbered the Spanish, so they might have successfully turned the tables once they realized that little fact.

De Gourgues should not be counted among those Menendez defenders. When he got word of the events at Matanzas, his smoldering hate-Spain sentiment went full flambé. It wasn't right. It wasn't fair. Even though he was Catholic himself, he was outraged by the treatment of French Protestants at Spanish hands. Unarmed prisoners had been murdered, the honor of France sullied. He wanted payback, and lots of it.

Which he wasn't going to get from the French ruler, Charles IX. France was in the throes of an internal conflict between Huguenots and Catholics, and a lot of the nobles sympathized more with Menendez than with the victims. Besides which the king of France wasn't ready to take on the king of Spain by making too much over the incident. Not only wouldn't Charlie retaliate, but he made it clear that he didn't want anybody else doing anything about the incident. Well, what are you going to do? You can't fight city hall.

But sometimes you can go around it. De Gourgues sold his inheritance and used his connections to outfit three ships. Concealing his purpose from his crew by a stratagem that we'll get to in a minute, he sailed for the New World in August 1567. Only when he arrived in the Caribbean did he reveal that his true mission was retaliation for the massacre of the Huguenots. Realizing that some of his men might not appreciate being deceived, he gave a speech. A great speech, on the need for justice and the restoration of French honor. It worked; his men were so fired up that they didn't even want to wait for the full moon before sailing for Florida through the treacherous waters of the Bahamas.

The little fleet finally arrived at their destination, the River of May, which we call the St. Johns River. It was the site of the former Fort Caroline, now renamed San Mateo by the victorious Spanish, where the events leading to the massacre at Matanzas had started. But when the French reached the river's mouth, they saw three forts glowering at them instead of one. Menendez had not only repaired the former French fort but also built two new fortifications to protect it. The place looked impregnable. And the Spanish lookouts were staring right at them.

So how did de Gourgues's flotilla get by these forts without being detected? It didn't. But the lookouts mistook the French ships for Spanish vessels and even saluted as they sailed past the forts. The French returned the salutes, to put the dons at ease, and then cruised north to a river now called the St. Marys.

There they were met by a group of Native Americans. A large group of Native Americans, armed and dressed for war. They did not have the appearance of a tourist welcoming committee.

But the French were greeted warmly, once they *parlez*-ed a few *vous* instead of throwing out an *¡hola!* or two. Mind you, the French hadn't been all that popular during the days when they had controlled Fort Caroline. But, after dealing with the Spanish for a year or so, these natives had become Francophiles. The locals demanded to know why the French had ever left the area in the first place. When the French started talking about their beef with the dons, the locals interrupted—"rudely," according to the chronicler— with their own complaints.

But if there was a disagreement about manners, and about who had the stronger grievance, there was a strong consensus about aims—deep-six the dons. They should sleep with the *pescado*. Or, better yet, the *poisson*. The French and the natives—the "French and Indian" appellation has been reserved for conflicts with the English—marched south toward the forts.

They waded across a tidal creek, cutting their feet on oyster shells in the process, and captured the first fort. Then turned its guns against the second fort. And captured it. And took its guns and marched on Fort San Mateo, the renamed Fort Caroline. The Spanish sent out a group of fifty men, but the French ambushed them. The remaining Spanish abandoned their last fort and tried to make a run for St. Augustine, but most were killed by disgruntled warrior types lurking in the woods. The French captured those the natives didn't kill.

So what to do with the prisoners?

Well, de Gourgues certainly wasn't going to kill his captives because of religious reasons. He wanted to make that clear. Why, he was Catholic himself. His speech was arguably the first address on religious liberty in the New World.

On the other hand, he couldn't help but notice that his prisoners appeared to be of the Spanish persuasion. So, after spending a considerable amount of time reviewing for them the numerous wrongs committed by their countrymen, he strung them up. All of them. First harangued, then hanged.

We can now point out a number of similarities, a symmetry if you will, between the life of Menendez and that of de Gourgues. Both were prominent seamen. Both were dedicated to their country, and each had financed his own expedition. Each had conquered through bold military action. Each, in later years, was given a prominent military command but died before he could assume the office—Menendez as admiral of the Spanish Armada, de Gourgues as admiral of a fleet Queen Elizabeth wanted to send to aid the king of Portugal.

Each had killed helpless captives.

And each left a placard justifying his actions.

Menendez's action seems, to modern sensibilities, most easily justified as a necessary act of self-protection. But his placard declared loftier reasons. It said that he had killed the men: "Not as to Frenchmen, but as to Lutherans."

De Gourgues's action appears, by contemporary standards, to be a matter of holding a group guilty for the acts of some of its members—the sort of thing the Nazis were criticized for when fighting the French resistance. But de Gourgues was anxious to avoid the charge that he killed simply because of nationality. His plaque read: "Not as to Spaniards, but as to traitors, robbers and murderers." It did not provide the evidence that proved these particular individuals were guilty of those crimes.

There were differences between the two men, of course. Menendez was commended by his king; de Gourgues was treated as an embarrassment by

his and basically exiled from court for many years. You could argue that de Gourgues was responding to a provocation—the massacre—that Menendez had committed. Historian George Fairbanks, writing in 1858, said, "That de Gourgues deserves censure cannot be denied, but there will always exist an admiration for his courage and intrepid valor, with a sympathy for the bitter provocations under which he acted."

On the other side of the coin, we could point out this. While Menendez was trapped on a savage coast with prisoners who outnumbered him, trapped because he had no boats to take either him or his captives away, de Gourgues had ships readily at hand. He could have safely sailed away if he had spared his prisoners. Fairbanks expressed neither admiration for Menendez's valor nor sympathy for the pressure of his circumstances.

Yet if de Gourgues was harsh, surely we can agree that he was a man obsessed with balancing the scales of justice, one who believed that those who mistreated others should themselves be punished. A righter of wrongs. Still, we might look at one more fearful similarity, this one between the beginning of de Gourgues's hatred of the Spanish and some of the circumstances of his final revenge. And to do so, we need to go back to that deceptive stratagem we mentioned earlier.

How do you get a crew across the ocean without them wondering what you're up to? Well, de Gourgues used the slave trade as a cover. He first sailed to Africa, obtained a shipload of human beings and then journeyed on to Cuba and sold them. It was after selling this cargo of misery that he revealed to his men the true purpose of their journey, the lofty one of punishing those who had harmed others.

So to avenge the killing of unarmed captives, this seeker of justice killed unarmed captives, and out of his hatred for the Spaniards who had enslaved him, he sold slaves to the Spaniards.

Hobbes said that consistency is the hobgoblin of small minds. In those days, mental giants sailed the seas off Florida.

CHAPTER 5

A Funny Thing Happened on the Way to the Office

Governor Ybarra Loses His Shirt

Have you ever had trouble getting to work? Pedro de Ybarra could swap some stories with you. He had gotten one of those big promotions that require you to move—in his case, the new job was governor of Florida. The good news was that it was a prestigious position and a step on the way to the big time. The bad news was that it was in Florida. Because, back around 1603, the state image wasn't so much the "Sunshine State" as "Jungle Outpost Beset by Blood-thirsty Cannibals." Now I didn't say there were cannibals there. We're talking image.

Anyway, how do you pack? You've got to figure that you'll be gone a few years, with no stores to buy stuff you forgot and no decent dry cleaners. On the one hand, you'll be the king's representative, a personal embodiment of the splendor and might of the Spanish Empire. On the other hand, you're going to be a frontiersman. You've got to be able to make an impression at a state dinner, and you've got to be able to fight a battle in the middle of a swamp. You never could tell when the bishop of Cuba might drop in for a little small talk and a glass of sherry. But you also couldn't tell when buccaneers like Francis Drake would be paying a visit—they were bad about never calling ahead of time.

OK, think it through. Don't forget the toothbrush this time. You'll need a good razor and a strop—that shaving with your sword stuff gets old after a few days of combat. Brocade, you'll need lots of brocade. And lace, for necks and cuffs. A halberd or two, so you don't have to keep borrowing one. Some

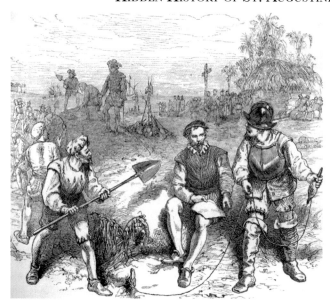

WHEN THE OLDEST CITY WAS THE NEWEST CITY. *The founding of St. Augustine.* In William C. Bryant and Sidney H. Gay, *Bryant's Popular History of the United States*, vol. 1. New York: C. Scribner's Sons, 1881–83, 213.

of those pleated collars that make your head look like it's sitting on a plate, several pairs of those what-were-we-thinking hose and slashed bloomers, a good suit of armor for dress occasions as well as a couple of changes of the everyday stuff…

Now you'll need a few embroidered doublets…Velvet always looks good on a doublet, but is it going to hold up to a Florida summer? Same deal with hats—those frothy feathers look great, but what're they gonna be like after a couple of nor'easters or a few stiff battles? You'll have your dress sword on you, but better pack something sturdier, an épée maybe, or perhaps a broadsword. Gonna need a shield, but it doesn't have to be fancy; that's just for outback expeditions. Gotta have some silk slippers for formal functions and a couple of pairs of thigh-high boots for wilderness raids. Wish they would hurry up and invent something besides wool underwear…

Cloaks…Probably don't really need them most of the time in Florida, but it does get cold there sometimes, and if you have to go out in a hurricane it'd be nice to have one. Now, helmets…Those conquistador-style *morions* are nice, but maybe you should take one of those closed-face jobs with a visor. They're out of fashion now, but one might come in handy if someone shoots a bunch of arrows at you.

And shirts. Lots of shirts. Florida gets hot and humid they say, so you might want to change clothes sometimes. Need a few of those silk things for dress up, and maybe a dozen linen ones for just hanging out…

And at last on his way. Sailing across the open seas, on his way to Florida. Not the best outpost in the empire, but not the worst either. No Aztec palaces, no Inca gold mines, just thatched huts and a wooden stockade. But if the capital "city" of St. Augustine was small, the province was big. Huge areas of countryside lay inside Florida's boundaries. De Soto and those other guys hadn't found any gold, but they hadn't looked everywhere. And who knew what other goodies might be lying around? This was going to be a challenge, maybe even fun—

That was when he saw the pirate ship. The first one. Then Ybarra's ship was being hunted by a whole pack of English corsairs. Being driven one way, then another, then cut off. Cannons firing, muskets blazing, clouds of sail closing in, the thud of ship striking ship. The buccaneers were boarding, yelling ugly stuff. He would never forget those faces…At least there was no layover in Atlanta on this trip.

And then Ybarra was somehow away from the fury, somehow aboard the ship's launch, slipping away from the pirates. Now alone on the open sea. Which way lay safety? There were probably islands all around, out of sight over the horizon, but not just any island would do.

There were those persistent rumors of cannibals. There were those confirmed reports of Europeans captured and tortured by the native tribes in those jungles, of Europeans kept as slaves. Which might have something to do with the fact that Europeans had been capturing natives as slaves and torturing those who resisted. In the meantime, Ybarra was lost on the open sea in his little boat. Where was he going to find drinking water? Food? This was worse than the airlines. He was tossed around for five days before he finally saw land.

So could a politician get the boat to shore by himself? Maneuver it safely through the surf to the beach? He had to, and he did. Now where was he? And how was he going to survive on what was probably a deserted island? His weapons, his travel chests, his fine clothes, everything except what he was wearing had been left on the ship the pirates had captured. He was more alone than he'd ever been in his life, just himself to depend on. Jungle on one side, sea on the other. Try walking the beach, see if it led somewhere or whether it might be possible to attract the attention of a passing Spanish ship.

And around the corner came some familiar faces. Those faces he'd never forget. The same pirates who had captured his ship. Five days of that hideous escape journey, and here he was where he would have been if he had stayed. At their mercy. Well, they had already gotten everything he had. Except his life, of course.

"Hey, look who's here!"

HAZARDS OF THE COMMUTE. *Attack on a Galleon.* Howard Pyle. *Howard Pyle's Book of Pirates*, compiled by Merle Johnson. New York: Harper & Brothers Publishers, 1921, frontispiece.

They had gotten everything he had, except his life. And the clothes he was wearing. Fortunately, they didn't want his life. Unfortunately…

Fortunately, they dropped him off on the coast of Cuba, which was the very best island for a Spaniard in the Caribbean area. Unfortunately, it was the wrong side; he needed to reach Havana, which lay across the jungle—a tough hike when the pirates had taken most of his clothes and his boots. Could a courier, skilled at maneuvering through the thickets of intrigue at court, manage equally well in an actual jungle? He would have to, and he did.

He walked across the island, living off crabs, snails and wild fruit. Trying to keep mosquitoes and jaguars and other wild animals from living off him. Hoping he wouldn't encounter more pirates or bandits. Were there still natives on this island? Could they possibly be friendly after dealing with his countrymen for a few years? He listened to the noises of the jungle as he walked barefoot toward what he hoped was Havana.

And it was. He finally reached the city and convinced someone to let this ragged personage see his fellow governor. He needed to borrow a frigate, for just a few weeks, to get to St. Augustine to start his new job. He was already running late.

Oh yes, and if possible, a clean shirt.

CHAPTER 6
THE PIRATES OF PAYNES PRAIRIE AND THE ACCOUNTANTS OF THE CARIBBEAN

This is one of those long-ago stories. It happened before they started calling Hogtown "Gainesville." Before there was a Hogtown at all, and even before there were any hogs in what would one day become Hogtown.

Thomas Menendez Marques was a Spanish nobleman, which meant he could use the title "Don." That was a pretty good thing to call yourself back in the 1600s—got you some respect, meant you impressed folks at your high school reunion. In Don Thomas's case, it also meant that he had some pretty good connections with the movers and shakers of the Spanish Empire, so he had some pretty good career prospects. That's why it was somewhat surprising when the Don resigned his position in St. Augustine and went off to become a cowboy in the middle of the Florida wilderness.

Actually, he went off to establish a large cattle ranch he called *La Chua* in the middle of a land grant his family owned. This grant included a good cattle-grazing area beside what is now called Paynes Prairie, near where the shining towers of Hogtown would someday rise. So you might think, "Big deal. Rich kid goes to cash in on his father's estate." But you have to realize that in the mid-1600s, people were a little reluctant to get out of St. Augustine at all. The interior of Florida was seen as full of truculent Native Americans and unknown dangers. Further, Spanish dons were not generally known for engaging in anything resembling manual labor. So we have to give Don Thomas some credit for courage, willingness to work and ability to see opportunity.

Because there was opportunity. True, the government required him to ship some of his cattle to St. Augustine. That wasn't terribly profitable, by

the time he drove the cows all that distance to the coast and filled out all the paperwork. However, he could take the rest of his livestock west to the San Martin River (which we call the Suwannee/Santa Fe), less than half the distance to St. Augustine. And once his cows were loaded onto boats, they could be shipped to Cuba. Where they had actual money. And not just money—rum. He traded cows for rum and rum for furs. Times were pretty profitable for the cattle-raising/rumrunning/fur-trading Don.

Unfortunately, this very profitable business attracted the interest of a second group of entrepreneurs—pirates from Anclote Key near Tampa Bay. In 1682, they sailed up the San Martin and then made their way to Paynes Prairie, where they captured Don Thomas, his son-in-law and four servants. As it turned out, there was a reason people thought it was dangerous to set foot outside of St. Augustine. The pirates also knew how to recognize an opportunity when they saw one, and they resolved to hold their noble prisoners for ransom—150 cows and a sack of money.

Now there are reasons to suspect that these pirates did not know the ins and outs of their line of work. The discerning eye will pick up on certain clues, subtle deviations from accepted business practices that alert one to the possibility of an amateur operation. To start with, the typical realm of a pirate is the open sea, while these pirates had chosen a target about as far inland as you can get in Florida. The Spanish Main provides a whole different context for the Jolly Roger than does a sandbar in the Suwannee, much less a field of cow patties.

Not only had these pirates traveled a considerable distance from the open sea, but the *La Chua* caper also required them to march far from a navigable river. If it is true that one of the major assets of a pirate band is their pirate ship, it is also true that such an asset is worth considerably less on dry land. On the other hand, it must be conceded that they achieved the element of surprise. We can only speculate on how long it took the nautical brigands to get the cowboys to take them seriously: "Don Miguel put you up to this, didn't he?"

But there is a second unusual feature of the operation to be considered, one that we might anticipate could lead to a loss of street cred for the buccaneers. Whereas it was the custom of the traditional pirate to go after gold and jewels, these corsairs were demanding meat. You have to wonder what their colleagues would think as they all stood around some Jamaican tavern boasting of their conquests:

"A lofty royal galleon, filled with Incan gold."

"The entire city of Cartegenga."

And our pirates say, "More hamburger than ten men can carry."

Still, while questions might be raised about their piracy, we must concede that their kidnapping was first rate. They had indeed captured Don Thomas. And they were surely among the pioneers, if not the originators, of cattle rustling in Florida. Perhaps they had anticipated the future importance of the cattle industry to that future state.

But all of this did not matter because before that lucrative ransom could be paid, a band of Potano warriors ambushed the pirates and rescued the captives. Thus, even if we concede the pirates' goals to have been sound, we must fault them for their execution in achieving those goals.

Now at this point, we have Indians attacking pirates to rescue cowboys, not to mention a Spanish don. I realize that it may sound a bit over the top, but I would like to point out that I am writing in the capacity of reporter rather than that of creative artist. That's just the way things were in the wild, wild Southeast of that day. Still, in order to tone things down I will mention that there was another profession involved in this incident.

Don Thomas had been trained as an accountant. In 1684, after the pirate raid, he inherited the position of royal accountant and had to move back to St. Augustine. You might wonder why the don agreed, why he was willing to leave the glamorous professions of cattle baron and hostage for what we think of as the sedate attractions of bookkeeping. But the profession was a different sort of enterprise back in the seventeenth century. Accountants had always played an important place in the history of St. Augustine, especially the ones in Cuba and Mexico. On one occasion, the accountants basically hijacked the supply ship that was supposed to go to St. Augustine—the one that carried the town's food and money for the entire year—and sent it directly to the king of Spain. More commonly, the accountants allowed much of the food to get through but convinced the royal treasury to withhold pay for the troops.

You read a lot about pirates and their repeated sacking of St. Augustine. But if my Internet-based calculations are correct (don't bet too much on it), Sir Francis Drake got about $100,000 (admittedly, back when that was real money) when he burned the town in 1586. Robert Searles got less than half that when he looted the place in 1667. And these were the successful pirate raids. There were other attempts, such as the one by our pirates of the Suwannee, that were unsuccessful.

But accountants took about four times as much as Drake during just one eight-year period by shortchanging the pay of St. Augustine soldiers. They

WELL, IT WASN'T ALL PIRATE RAIDS. *Scene in St. Augustine.* William A. Crafts, *Pioneers in the Settlement of America*, vol. 1. Boston: Samuel Walker and Company, 1876, frontispiece.

used a fraction of this back pay to finance the building of the Castillo de San Marcos; the soldiers paid for their own fort, with a bundle left over. Clearly, the accountants made out much better than the pirates. So when the pirates messed with Don Thomas, it was a case of amateurs taking on a pro.

Of course the glory days of swashbuckling accounting, when mighty financial institutions could be looted of fortunes by dubious bookkeeping, are long gone. In these sedate days of Madoff and Enron and WorldCom, accountants are left to merely dream. But back then, you could see where the profession might have had a certain edgy image that could draw a young man with a yearning for adventure away from the day-to-day drudgery of cattle baron or even pirate chieftain.

Still, a couple of questions remain: First, since the Castillo cost more than twice the total amount that pirates stole over the years, couldn't the crooks have been bought off cheaper? Second, given that accountants stole so much more than the pirates, why is it they have received so little recognition over the years?

In all justice, shouldn't we have an "Accountants of the Caribbean" ride at Disney?

CHAPTER 7

Was Sotolongo Really So Wrongo?

It was a long time ago, before the Oldest House was the Newest House, before the first furrow had been plowed at the Alligator Farm. It was so long ago that you could get through a meeting without a cellphone interruption.

The year 1668 was a terrible one in St. Augustine. There had been a big storm—and I know what a lot of you are thinking. One storm! Wimps! A lot of us have experienced four hurricanes in a single year. But you have to realize, the town had been without power for over one hundred years, and there wasn't an electric company truck in sight. And besides, a lot more had gone wrong. Two ships had been lost at sea. There was a drought. For the Grand Climax, the town had been captured by the buccaneer Robert Searles—aka John Davis, aka some really harsh names the townspeople used for him. The pirates had begun by capturing the annual Spanish supply ship, called a *situado*, and used it to sail unchallenged into the harbor. Everyone was so happy to see the long-expected ship that no one wanted to question it too closely. Besides, the marauders even had the recognition signals needed to get past the guns of the wooden stockade that served the town as a fort back then. They anchored in the harbor, rowed ashore in the middle of the night and then chased the citizens into the woods and kept the soldiers penned up in the fort while they sacked the town.

Same ole, same ole in St. Augustine.

But a priest named Sotolongo thought it was no accident that the town had been afflicted with the pirate raid at this particular time. He claimed that the calamities of that year came about because the governor, Don

Francisco de la Guerra y de la Vega, was messing around with an unmarried local woman.

Have you ever heard of such superstitious nonsense? Blaming a pirate raid upon a governor's private misconduct? But we must remember that those were different times. In that distant and benighted era, a medical crisis such as a heart attack was often blamed on personal sins such as gluttony or sloth. Of course we, in these more enlightened days, understand that such illnesses are more likely to be the result of overconsumption of high-calorie foods or inadequate exercise.

In any case, when we hear that story about the priest, we figure we have him pegged: Sotolongo was probably an uptight, narrow-minded bigot, always worried about other people misbehaving. But it turns out that he was concerned with a lot more than sex.

Not content with stealing valuable goods, the pirates took prisoners— Africans, Native Americans and mixed-blood people were seized and forced down to the waterfront to be loaded onto the pirate ship and later sold as slaves. The townspeople might have objected, but they cowered among the trees and palmetto, too frightened to show themselves. It was then that Sotolongo stepped forth and confronted the brigands. He pleaded with them to release the captives, boldly insisting that these nonwhites were as much citizens of the Spanish Empire as were dons of the purest blood and as dear to the king. He even offered to find ransom for the prisoners.

The English pirates resisted appeals to either mercy or financial incentives, saying that they had been authorized to enslave anyone not 100 percent European. Still, Sotolongo had tried to save the prisoners, at considerable risk to his own life. These were ruthless killers, not used to being confronted and by no means kindly disposed to Catholic priests.

So perhaps there was more to the man than we might have thought at first. And perhaps we should at least investigate his charges.

First, was the governor really fooling around? Some circumstantial evidence suggests that he was—he was living with an unmarried woman named Dona Lorenza de Soto y Aspiolea, and they had three illegitimate children. Now, there might have been a harmless explanation, but we can certainly understand how the priest's suspicions could have been aroused. Mind you, the governor and the lady would have pointed out that there were extenuating circumstances. To start with, Dona Lorenza truly fell in love with the governor.

She lost her heart to Don Francisco.

And the feeling was reciprocated—the governor truly fell in love with her. So why didn't he just marry the lady? Well, the Spanish king had a policy at

the time that forbade his officials from marrying local women. Spanish blood, at least noble Spanish blood, must be kept pure. Was it really reasonable to expect healthy young bachelor officials to remain alone for years, with no romantic attachments? The king didn't care about that; he just didn't want his officials to marry locals. There were probably some unscrupulous officials who took advantage of the situation: "Of course I want to marry you, baby, but the king of Spain won't let me."

However, we have proof that the governor was not one of those men. Some years later, within weeks after his term of office was up, the ex-governor married his Dona Lorenza. If it is true that she lost her heart to Don Francisco, he truly lost his to her as well.

Still, at the time of our story, there was evidence that the governor was involved with an unmarried woman. Even if Sotolongo had sympathized with the lovers, it would have been difficult for a priest to publicly approve of a couple living together without the benefit of marriage. But how about the rest of the charge? Does it really make sense to claim that this liaison was responsible for the depredations of the buccaneers?

Before we can answer, we need to investigate the raid more closely. And when we do, the first thing we notice is that the timing was suspicious. In those days, St. Augustine was not ordinarily a promising target if you were after plunder. The city was a military outpost, not a mining community pulling out gold or silver from the earth, nor the center of some wealthy Native American empire, nor a gathering place for treasure galleons. Not only wasn't St. Augustine a likely place for finding vast wealth, but it wasn't even a good bet for a mugging—the troops were rarely paid. To tell the truth, the city wasn't even a good bet for a sandwich, because the town didn't grow enough food to feed itself; famines were common.

Yet there was treasure in town at this particular time. A shipwreck had been salvaged, and 138 silver marks were stored in town until they could be shipped back to Spain. That was the precise moment that Searles's men sailed into the harbor. How did the pirates know to strike just then? Also, how had the buccaneers known so much about the town's defenses and their weaknesses? How, for instance, did they know to use the disguise of a supply ship as cover? And how on earth had they obtained the recognition signals?

The more we find out about the raid, the more it starts to look like an inside job.

And it was. It turned out that the pirates got their information from a French physician who had lived in the town, a man called variously Pierre Piques, Pedro Piquet or that French dude who snitched us out. He had been

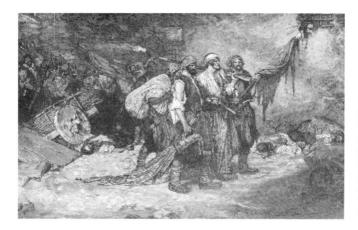

EARLY TOURISTS. *Sacking of Panama.* Howard Pyle, *Howard Pyle's Book of Pirates*, compiled by Merle Johnson. New York: Harper & Brothers Publishers, 1921, 20.

leaving St. Augustine when his ship was waylaid by the brigands. The good doctor had apparently taken this opportunity to tell them about the treasure and the city's defenses. So the pirate raid occurred when it did because Pierre decided to help the enemy. Why had he done such a thing? Because he was angry at the town. So surely the real reason for the pirate raid wasn't the governor's dalliance at all, but rather—Piques' pique.

Still, we might go on to ask why Piques was piqued. And here we discover that he was angry at St. Augustine for good reason: he had been treated badly. Piques, after he had been working as a physician for the governor for some time, demanded the wages he was owed. The governor promptly gave the money to him but then took it back on the ground that the physician was French—a condition that you might have thought the governor would have noticed before now. As a parting gift, the governor even slapped him. Don Francisco sent the doctor away with no money and a stinging cheek, probably chuckling, "Do your worst."

At which point the pirate ship showed up.

So Sotolongo might have had it partially right—it, to some extent, was the governor's fault. But come on; it still had nothing to do with the governor's affair.

Or did it? Why did the governor treat the French physician so badly in the first place? We don't really know. But rumor had it that the governor was urged to do so by some of the women of the town. Could one of them have been his girlfriend, Dona Lorenza? Whose opinion he would not have taken so seriously had he not been in a relationship with her?

And so at last we are forced to ask: was Sotolongo really so wrongo?

CHAPTER 8
POKER

In chess, moving a castle into place projects power across the board. In the late 1600s, Spain slid a castle into position on the Florida coast, and it projected power across the Southeast. The Castillo de San Marcos in St. Augustine was designed to protect the treasure fleets and stop the southward encroachments of the English into Spanish territory. Once the fort was completed, it did a pretty good job, standing up to two English armies and numerous raids. It was never taken by force. But in 1683, the Castillo had its first test. And it wasn't ready.

Although the fortress was to eventually defy invasions by other countries, it was built because of pirates. And not just any pirates. Buccaneers. Those seagoing bad boys of the sixteenth and seventeenth centuries were a pretty macho bunch, not like the effete dilettantes of the 1700s that you usually read about. Blackbeard and his colleagues merely captured ships; they were like those modern-day criminals who knock over banks and armored cars. Those old guys of the 1600s would have knocked off Jacksonville if it had been around. Since it wasn't, they developed the habit of sacking St. Augustine every few years.

There was a certain routine to the business. The buccaneers would attack the town, and if they won—as they usually did—they looted the place and burned it to the ground. The town would rebuild, and then the next batch of pirates would repeat the process. But in 1668, the pirate Robert Searles broke with tradition. He captured and sacked the place, all right, just as custom dictated, but then he failed to set it ablaze. Well, that was the last

straw for the Spanish. Enough was enough. There were certain expectations that had to be met, traditions to uphold, a right and a wrong way to do things. If the pirates weren't going to do their part by burning down the town, well…why should the Spanish stick to routine if the pirates would not?

Besides, you had to wonder: why did the pirates violate custom? If the pirates didn't destroy the town, perhaps it was because they planned to come back and stay. And sure enough, that's what the prisoners confirmed once the Spaniards ransomed them back. The buccaneers were being careful with St. Augustine because they planned to own it in the near future.

So the Spanish decided they had better build a real fort to replace their rotten wooden stockade. A powerful fortress, made out of stone. A castle. Rook to Matanzas Bay.

The governor and all the officials held the formal groundbreaking ceremonies on October 2, 1672, and the fort was projected to cost $47,000—a lot of money in those days, but worth it. After filling out the elaborate paperwork to get the necessary building permits, and changing the plans a couple of times, and the usual construction delays, the structure was completed twenty years later at a cost of $220,975.06. Cost overruns are a state tradition that continues to this day.

But money was no object. Some creative financiers—probably Don Garcia de Madoff and Diego y Citibank—had located a source for the funds—the money set aside for the back pay of enlisted men. Heck, the soldiers were the ones who were going to benefit from protective walls, right? So they should pay for them. Anyway, they'd probably just waste the pesos on food for their families.

In the meantime, the pirates—the ones on ships, not the ones in the treasury—had decided to pay another visit to St. Augustine. You get busy with pillaging and looting, you find yourself distracted by plundering, and then one day you look around and discover that fifteen years have gone by since you captured St. Augustine. So, in March 1683, the buccaneers figured they were past due to try it again. They had a cunning plan: they would row up the Matanzas River and attack the city from the rear.

Fortunately, there was a watchtower at Matanzas to thwart just such a tactic. Unfortunately, the guards were asleep and were easily captured. Fortunately, a Captain Uriza happened to be delivering a message just then, and he got word back to St. Augustine. "The pirates are coming! The pirates are coming!"

Well, at least the town had a fort now. Almost. But a few of the final touches were still lacking. Like the gate, for instance; there was just a hole in the wall. Oh yeah, the walls were missing too. Or at least the upper parts of the

curtain walls between the diamond-shaped bastions on the corners. The Spanish did have some cannons for the fort, but the guns had not been mounted on carriages yet. The truth is, the place was a lot closer to a construction site than to a military installation. But how much of this did the pirates know?

The governor moved the regular troops, militia and families into what would one day be the Castillo. He set everybody to work, stacking stones without mortar to make the

Fortunately, the Inlet Was Guarded. *Matanzas in 1671.* Drawing by Albert Manucy, 1954. In *El Escribano* 17 (1980): 4.

walls a little higher. Mind you, the place wouldn't have stood up to cannon fire, but it did look more impressive that way.

While the plan was the best that could be devised under the circumstances, it was almost thwarted by a stylistic mismatch between the governor's inspirational techniques and his audience. Not to put too fine a point on it, he had a potty-mouth. "Bend your backs to the task" came out in a fusillade of profanity. "We must work more efficiently" caused the night to crackle with crimson vulgarity. Instead of "speed is of the essence," a cloud of politically incorrect words thundered through the dark.

Those assembled in the fort—the delicate sailors, the naïve frontier soldiers, the grizzled army veterans experienced in military but not verbal assault—were strongly offended. They felt as though their sheltered ears had been slapped by the rough side of the governor's tongue, by his rude tone and his deplorable word choices. And him a gentleman! The entire construction crew stopped what they were doing and muttered darkly of mutiny. There was such a thing as the dignity of labor and a limit to what workers should have to endure.

Now it might be supposed that language such as that used by the governor would be even more offensive to clergy. Nevertheless, it was the chaplain who recommended patience to the shocked citizens and who pointed out that the pirates remained a dangerous threat worth considering. Certainly he could not condone the governor's salty words, but there was something to be said for not being killed by brigands. His appeal was heeded, and the men returned to work. So the priest was the first hero of the siege.

The next day, the Spanish got word that forty pirates were marching up Anastasia Island. The governor sent one of his officers, Captain Arguelles, with thirty men to intercept them. But the intelligence was faulty, and the pirates actually had two hundred men instead of forty. Nevertheless, the ambush worked; the brigands were so surprised by the bold attack that they retreated. So Captain Arguelles was the second hero of the siege.

But the game wasn't over. As the pirates withdrew, they captured a Spanish soldier, Private Francisco Ruiz. And now they wanted information. They knew about that new fort, and they knew the construction wasn't finished. Their question was, how close to completion was it? Was it a usable structure yet? Were the walls high enough, did it have enough cannon in place to defend itself? If so, the pirates wouldn't be able to capture the thing. But if not, then there would probably be some good stuff lying around for the taking. And so they were very interested in hearing what Ruiz had to say about the matter.

It was most unfortunate for the private that he was the one captured. But it was most fortunate for St. Augustine. Because Ruiz lied like it was election year. And he lied well. He told the pirates that the fort was indeed far enough along to be defensible. Oh, sure, it still needed a coat of paint and a set of drapes, but that sucker was ready to get it on. Not only that, Ruiz swore, but the Spanish had enough men to set ambushes at any landing spot the pirates might care to try. Overall, he made an attack on the fort sound like a very bad idea.

But was he telling the truth? The pirates were skeptical. Another prisoner, captured previously, had told them that the Castillo was incomplete and St. Augustine an easy mark. Who to believe? So they tortured Ruiz. They tortured him at length, all through that long and ghastly night. And he told the same story. Again. And again. So Private Ruiz was the third hero of the siege.

The pirates still didn't know what to do. They sailed north, to the mouth of the harbor, and looked at the fort across the bay. It was clearly unfinished. But how unfinished? It wasn't a thing of beauty yet, but was it serviceable? Ruiz had said that it was. Could they trust the soldier, even after torture? It would be easy enough to find out—sail within cannon range. But if they got that close, and the fort was operational, they would never sail out again. On the

But What If He's Not Bluffing? *The Spaniards Gambling.* In Benson J. Lossing, *Our Country*, vol. 1. New York: Henry J. Johnson, 1878, 101.

other hand, if the fort wasn't ready for action and the pirates failed to strike, they would miss their last chance to take St. Augustine. Because the Spanish would surely have finished the project before the pirates could come back.

It was Don Dirty Harry time. The question for the bad guys was, "How about it, varlets? Dost thou feel felicitous today?" "Do ya feel lucky?" They waited. They thought. They weighed their options.

And they folded. The pirates sailed away, unwilling to risk an assault. The Castillo San Marcos had met its initial test, had defended the city for the first time. Even without mortar on the upper stones, without mounted cannon in place. Even without a gate. Thanks to Ruiz, the bluff had worked.

In chess, when you move a castle into place it projects power across the board. In the late 1600s, Spain slid a castle into place along the Florida coast, and it projected power across the Southeast. But in 1683, the game wasn't chess.

It was poker.

CHAPTER 9

TWIST OF FATE

The story of St. Augustine is the story of pirates. Our founder, Pedro Menendez, made his reputation as a pirate fighter off the coast of Spain. The French presence in Florida was discovered because deserters from Fort Caroline turned pirate and were subsequently captured—their information about the French colony brought Pedro Menendez to Florida. One reason for founding the town was to help protect the Spanish treasure fleet from pirates. But the town needed pirate protection itself; St. Augustine was burned by the buccaneer Sir Francis Drake twenty-one years after it was founded, and it was harassed by other pirates over the next century. One of our governors, Ybarra, was captured by pirates on his way to take office. The Castillo de San Marcos was built because of one pirate raid too many, and while it was still a construction site, it managed to bluff a band of pirates into retreat. So you can see why, when the Spanish captured Andrew Ranson on shore in 1684, they assumed that he was a pirate.

He denied the charges and claimed he had just come ashore to hunt game. However, his fellow sailors who had been captured with him said that the charges were true. Admittedly they may have been tortured first, which tends to increase the rate of confessions to most anything. But other evidence supports the pirate theory. The commander of their squadron was Thomas Jingle, a notorious New England pirate, and Ranson himself had a reputation as a pirate in Key West. In any case, when Ranson came to trial, the tribunal weighed the evidence and found him guilty. The governor promptly sentenced him to death.

THE OLD PIRATE-ON-LAND MISTAKE. *Marooned.* Howard Pyle, *Howard Pyle's Book of Pirates,*
compiled by Merle Johnson. New York: Harper & Brothers Publishers, 1921, 26.

Death by garrote, which was a nasty kind of slow-motion hanging. A
rope was looped around a man's neck and then run through a hole in a
post. The executioner used a stick to twist the rope until the man choked to
death. I'm not clear on the merits of garroting over alternative methods of
execution; I suppose death by firing squad was a hassle with muzzleloaders,
and beheading was messy. Perhaps the preference for extended executions
had to do with the fact that all of this took place before YouTube, which
meant the main source of entertainment was either running from pirates or
executing pirates—and most people seemed to prefer the latter.

Mind you, not everybody was in favor of executing Andrew Ranson. He was
a Catholic, and he made friends with some of the local priests, who happened
to be no fans of the governor. They begged for Ranson's sentence to be
commuted, but His Excellency refused. This was no time to be soft on crime.

So the fatal day arrived, and Ranson was led to his doom. He was
placed by the post, and the deadly hemp was put around his neck, threaded
through the hole in the wood. The rope was twisted by the executioner,
tighter, tighter. Ranson struggled in vain. Twisted more. And more. Ranson
slumped, unconscious. The rope was twisted once more, for good measure.

Whereupon it suddenly broke. Ranson's body fell to the ground. What to
do? The soldiers, the officials, looked at one another in bewilderment. This

hadn't happened before. Shouldn't have happened this time—it was a new rope, it had been inspected before the event.

The priests surged forward to claim the body and took it into the town's church. He was out of government jurisdiction now. The priests dumped the body near the altar and began to discuss plans for the funeral service.

Which was when Ranson woke up.

He saw the altar and began to pray. Between the rope breaking and the "corpse" reviving, the priests wondered whether this was some kind of miracle. Ranson himself didn't have any doubts. Well, it was the sort of thing that gets talked about.

> *Word went out to the taverns,*
> *Word flew to the town hall;*
> *Word was sent to the governor,*
> *And that was worst of all.*

His Excellency was furious when he heard what had happened; he sent soldiers to retrieve the fugitive and finish the job. But Ranson was sheltered inside the church now, and the priests insisted upon the ancient right of sanctuary. Sanctuary! Such a Medieval concept, almost like "mercy." It didn't seem to fit with the progressive and efficient modern world. But the ancient law had not been repealed, and the soldiers were afraid to defy the priests. So Ranson stayed under their protection until things cooled down. And he stayed alive.

He was eventually allowed to leave the church, and in time he became a valued citizen of St. Augustine. In future years, that broken rope was often carried in religious processions. Now there's one more twist—so to speak. Ranson had some engineering expertise, so he was hired to help with the ongoing construction of the fort.

The history of St. Augustine is a history of piracy. The town was built to protect Spanish treasure fleets against pirates, and the fort was built to protect the town. Andrew Ranson was the pirate who helped build the fort.

THE CHRISTMAS SIEGE OF 1702

Previously published in the *St. Augustine Record*

It happened a long time ago, before DVDs—or even BVDs. It was so long ago that no one knew food was bad for you. The memory of living man goeth not back so far, although the written records aren't too shabby. It took place during the holiday season of 1702.

Three hundred years ago, things were different in St. Augustine. The Castillo de San Marcos was brand-new and decked out in Santa Claus colors, its white walls freshly plastered and its watchtowers gleaming red. The moat was filled with cows. The courtyard was filled with every civilian in east Florida. And the town...well, the town was toast. Half of the houses were in ashes.

Fifteen hundred people crowded into that shiny new fort. These days, we worry about getting our shopping done in time. Three hundred years ago, the citizens of St. Augustine worried about whether the food would last, about all those English guns pointed at them and about the trench zigzagging its way toward the fort. They worried about whose ships would arrive first. Because the town was under siege.

South Carolina invaded Florida when the king of Spain died. It was called the War of the Spanish Succession, or Queen Anne's War, and all of the European countries were fighting one another. Because the conflict spilled over into the New World colonies, some people call it the First World War.

The folks from South Carolina had heard about St. Augustine's brand-new fort, and they were afraid it would get used as a base of operations to

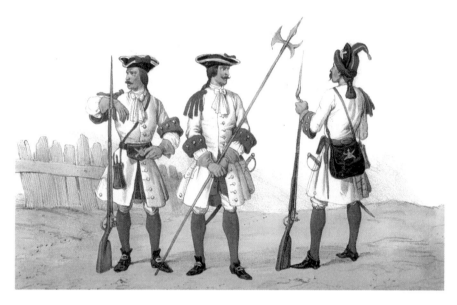

LOOK SHARP, FEEL SHARP, FIGHT SHARP. *Three Spanish Soldiers from Late Seventeenth/Early Eighteenth Century. Historia Orgáanica de las Armas de Infantería y Calalleria Españolas.* Toma II. El Conde Clonard. Madrid 1854.

invade Charles Town. So they figured they would take it off the board by striking first. The embarrassing part is that they weren't worried about the Spanish; they were worried that the French might take over the fort. St. Augustine was the Rodney Dangerfield of North American colonies at the time—it didn't get much respect.

So the British were coming, the British were coming. They were coming by land *and* by sea. A fleet of ships loaded with troops sailed to Florida while another army marched overland. And St. Augustine didn't need Paul Revere or lanterns in the North Church tower to raise the alarm, because the enemy announced themselves. They slashed and burned their way down the coast, destroying missions and ranches and trading posts, chasing refugees before them.

The English had 1,000 troops and fourteen ships. The Spanish governor, Joseph de Zuñiga y Zerda, had 174 regular army troops and 300 men from outside the fort, men who might or might not know how to fire a musket effectively. The fort was new, but it had old artillery pieces that were almost as dangerous to the people who fired them as to the enemy. So what St. Augustine had was trouble.

The governor sent messengers to Pensacola, Mobile and Cuba begging for help. But did the messengers get past the enemy? And if they did, could

anybody help? The defenders couldn't be sure, so they burned their own town to deprive enemy sharpshooters of cover. It became necessary to destroy the city in order to save it.

Things moved pretty quickly once the enemy reached St. Augustine in early November: you had the naval action, the exploding cannon and…oh, yes. The cattle stampede.

When the British fleet arrived outside the harbor, two Spanish ships were laying at anchor. One had to be sunk, and the other was just barely able to sneak out the back door of Matanzas Inlet at the last minute. The last ship carried one more desperate plea for help. It made it to the open sea—but the Atlantic was the British home court at the time, so who knew how far it got? Meanwhile, back at the fort, one of those old cannons blew up and killed the men who serviced it. The siege had just begun.

Things seemed to be going South Carolina's way. But the British troops weren't about to get overconfident; they were far too experienced for that. So they kept a wary eye on the fort, watching for the slightest sign of a counterattack. They were ready for an all-out infantry charge, or snipers, or night raids, or—

GOING WITH THE CHEAPEST BID. Cannon that exploded during the Christmas Siege of 1702. Exhibit in *Castillo de San Marcos*. *Author's collection.*

Which is when they were hit from behind. By a cattle stampede. Spanish cowboys from the countryside figured that the people in the Castillo were going to need beef, so they drove 164 head of livestock straight through the English lines. I suspect that the field reports were interesting and comments made by the high command colorful.

And then things slowed down, as the two sides settled into the routine of a siege. The English cannon fire hit the fort but couldn't damage the soft coquina walls. The Spanish didn't have enough men to sally forth and chase away the enemy. It was stalemate as they waited for the holidays.

All the English wanted for Christmas were special cannon, called mortars, which could send shells over the walls to drop into the courtyard of the fort. They had sent to Jamaica to get them. All the Spanish wanted for Christmas were reinforcements, and they had already sent several pleas for help. Which side would get what it needed first? The siege would be decided by a race. But were the Spanish in the race? Had their messengers gotten through?

On December 24, the defenders sighted a sail. Then another. They saw two ships come sailing in, come sailing in. They saw two ships come sailing in, on Christmas Eve in the morning…and what *was* in those ships all two? And whose ships were they? By noon they had an answer. The ships were English.

So on Christmas Eve 1702, the Spanish situation was this. They had been besieged in the Castillo for almost two months, with no end in sight. They had been forced to burn their own homes. The English had dug a trench to within pistol shot of the fort. Two ships had just arrived to reinforce the enemy, and those ships just might have the crucial mortars that could destroy the fort. There was no way of knowing whether their calls for help had gotten through at all, much less whether someone would respond. Morale was at a low point in the Castillo.

But Governor Zuñiga had one more weapon at his disposal. On the night of Christmas Eve, he threw a party. He ordered harps and other musical instruments played. There were drummers drumming. There might have been lords a-leaping and ladies dancing. With the cattle in the moat, it is possible that there were bulls a-bellowing. And there was certainly gold a-ringing.

The governor ordered that a Christmas bonus be distributed to the troops. Now in those days, it was rare for soldiers to get their regular pay; to get a bonus was extraordinary. The accountant and the treasurer tried to talk the governor out of it, of course, saying the garrison couldn't afford it. The governor explained they would just have to take it out of next year's budget, because there would be no garrison and no town if they couldn't raise morale. So for a few hours on Christmas Eve at least, there was good cheer.

On Christmas Day the two English ships, a sloop and a brigantine, entered the harbor. There were probably few gentlemen resting merry in the Castillo that day. But they had nevertheless been blessed. Those English ships did not carry the deadly mortars that could have destroyed the fort.

The next day was December 26, called the Feast of Stephen. Good Governor Zuñiga looked outdoors on the feast of Stephen. And what he saw was a fleet of ships. The Spanish relief fleet. His last messenger, on the ship that snuck out the back door of Matanzas at the last minute, had gotten through to Cuba. Help was here. St. Augustine was saved in the St. Nick of time.

Well, there is a lot more to the story. The British got away because the commander of the relief fleet landed green troops instead of black troops; he didn't want to risk his crack company of experienced black veterans, so he sent in a group of inexperienced soldiers. The English had to burn their own ships because the Spanish fleet had trapped them in the harbor. They also burned what was left of St. Augustine as they left town, which is why the Oldest House in the Oldest City isn't the oldest house in the country. You can have old buildings or you can have history, but you usually cannot have both. The Spanish later went north on a raid of their own, which didn't accomplish much.

But basically, once the Spanish fleet arrived on the Feast of Stephen, the Christmas siege of 1702 was over. Florida was going to stay Spanish for a while. Ever since then, people from UpNorth have been coming to St. Augustine near Christmastime, and some stay for the winter. And ever since then, people from Florida have been going to the Carolinas whenever they get a chance. It all started with the Christmas Siege of 1702.

And if it hadn't been for that heroic defense of the Castillo, we'd probably all be speaking English today.

THE REMARKABLE EAR OF ROBERT JENKINS

Ears don't get the respect they deserve, but they do rate mention in the classical literature. There are the sinners' ears, which hear not. There are those patriotic ears that friends, Romans and countrymen were requested to lend. There is Van Gogh's ear of unrequited love. Ears are even associated with the history of warfare. Ancient Rome was saved because the ears of Roman geese, though invisible, were nevertheless keen enough to hear the stealthy approach of a Gothic army. And common sense tells us that the history of warfare would have been far different without ears to hear the trumpet's call, the drum's cadence, the rebel yell or the battle cry of freedom.

Yet so far as I know, there is only one war named for an ear. And note: not a pair of ears, but a single ear. An ear that was discussed at length on the floor of Great Britain's House of Parliament. An ear that was to be a *causus bellum* of a great conflict—a conflict that set ship against ship on the high seas, that sent armies marching up and down the southeastern coast, a conflict that was to threaten St. Augustine and to test its Castillo. This influential ear belonged to Robert Jenkins. And the war was called the War of Jenkins' Ear.

It was in the year of 1739 that Robert Jenkins stood before Parliament, his hair pulled back to reveal a missing ear. And he recounted to the assembled dignitaries the circumstances by which he had suffered that loss. He told of how the Spanish had stopped his brig off the coast of Florida to search for contraband. Of how, not content to stop a British ship upon the high seas, they struck an ear from his own head. And now Jenkins took from his pocket an object wrapped in cotton cloth. He carefully unfolded the cloth and

MORE VISITORS FROM UPNORTH. *Oglethorpe Attack on St. Augustine.* In William C. Bryant and Sidney H. Gay, *Bryant's Popular History of the United States,* vol. 2. New York: C. Scribner's Sons, 1881–83, 561.

displayed its contents: the very ear of which he spoke. He trusted Parliament to take appropriate action. And they did. Outraged by the cruelty of the Spaniards, moved by the plight of Jenkins, they called for war.

There were many in England and the American colonies who were pleased to see war come. Spain permitted only limited trade between its colonies, including Florida, and Britain. Merchants wanted access to Spanish colonial ports. And there were other considerations. Ships laden with gold and riches sailed from Mexico and Peru to Spain, protected in part by Spanish arms based in Florida. If Spain's Florida bases could be eliminated, then the treasure fleet might be easy prey. And there were those escaped slaves from English colonies to whom the Spanish granted freedom. James Oglethorpe, colonial governor of Georgia, had been advocating an attack on St. Augustine and Spanish Florida for some time.

But Jenkins's ear was the atrocity that rallied public opinion and unleashed the war.

In May 1740, Oglethorpe struck. He captured Spanish river forts and closed the St. Johns to Spanish ships. He burned Spanish missions and the little town of Picolata. Then he took six ships, an army of two thousand men and heavy artillery and set out to destroy St. Augustine.

St. Augustine was prepared for such an eventuality. It placed a flotilla of small vessels in the harbor's entrance, preventing Oglethorpe from getting his naval guns close enough. When the governor sent his crack highlander troops forward in a land assault, they were stopped north of town by Fort Mose, a small fortification manned by freed slaves—most of whom had fled Oglethorpe's Georgia. The governor had to be content with bombarding the town at a distance, from the marshes of Anastasia Island. From there, the shells could hit the Castillo, but they either bounced off the walls or got stuck in the soft coquina stone. No matter; Oglethorpe could starve the Spanish out because he controlled the harbor entrance.

What he didn't control was Mosquito Inlet, sixty miles to the south, and he didn't realize the Spanish could get supplies by means of the nautical back door that we call the Intracoastal Waterway. So, in the end, with hurricane season approaching, Oglethorpe had to ignominiously slink home with his troops and ships.

But that wasn't the end of the War of Jenkins' Ear. Two years later, the Spanish retaliated with a march on Georgia's Fort Frederica, on St. Simons Island. They were ambushed at the Battle of Bloody Marsh and sent back to St. Augustine. Oglethorpe tried again, sending Native American troops to raid Florida. They were turned back at the city gates.

At last, the glorious war sputtered to an end. A lot of farms had been burned, a lot of Native Americans had been displaced, a lot of soldiers had died. But Florida was still Spanish and Georgia was still British. Oglethorpe returned to England with his ambitions unfulfilled.

And Jenkins? He still had no ear. He did have something else, however. After his appearance before Parliament, he was given a lucrative appointment as an East India Company supervisor on a tropical island.

And the ear itself? It had a number of unusual characteristics. First, the fact that it was preserved at all; such souvenirs are not usually collected during armed confrontations. Second, the fact that it had been preserved for the seven years between the infamous boarding incident and Jenkins's appearance in Parliament. Finally, the fact that the ear later turned out to be made of rabbit skin. Now, Jenkins really had lost an ear, as all could see. But some claimed that the ear had been removed not on the high seas, but while Jenkins was in the stocks for some petty crime.

The island Jenkins lived on as supervisor for the East India Company was called St. Helena. It was to have another famous resident some years later, a man by the name of Napoleon Bonaparte. But that's another story.

Lucky Pierre

OK, "Lucky Pierre" wasn't his real name. I don't think. In the interest of full disclosure, I don't know what his name was, and I'm not sure anybody else does either. Records weren't all that good in those days, especially if your name didn't start with "Lord" or "Don."

Not only wasn't our man noble, but he also wasn't a general. In fact, he wasn't an officer at all. He didn't even belong to one of the elite units of the army, like the grenadiers. So I don't call him "Lucky" because of his exalted rank or position. You might wonder why we should bother with his story at all, but he did play an important role in the "Bloody Marsh" campaign way back in 1742. Back when Florida invaded Georgia.

Lucky Pierre really wasn't a soldier; he was a sailor. And he wasn't English or Spanish, although those were the two countries involved in the battle. Pierre served on a French ship that happened to dock at Frederica, on St. Simons Island, in the new English colony of Georgia.

Now, it is possible that he was an adventurous lad, excited by this chance to see the New World, that he was one of those bold spirits always pulled by an urge to discover what lay over the horizon. On the other hand, given the way things seemed to work out for Pierre, I believe that it is also possible he was shanghaied and dragged off to the North America wilderness kicking and screaming. But anyway, I don't call him "Lucky" because I think he was fortunate to find himself in the right place at the right time.

On the contrary. Pierre and his shipmates found themselves in the middle of the War of Jenkins' Ear once they arrived at Frederica. Two years earlier,

the English governor of Georgia, Oglethorpe, had decided to invade the Spanish province of Florida and had gotten his teeth kicked in. Once he reached St. Augustine and ran up against their RHF—Really Humongous Fort—he had to retreat back to Georgia with his tail between his legs.

But the Spanish weren't inclined to let bygones be bygones. The British had invaded twice and might be tempted to do so again. Besides, the colony of Georgia was planted on what the Spanish considered to be Florida turf. Enough already. So, just when Lucky Pierre and his shipmates were thinking about getting the heck out of the war zone, the Spanish decided it was payback time. The Spanish governor, Montiano, came north with a fleet and an army. Nobody was going anywhere, and that included the French ship. Lucky Pierre was stuck.

There was worse to come. It would have been a little risky to sit out a war on a neutral ship in a harbor, but at least they wouldn't be in the middle of a battlefield. Oglethorpe fixed that. The Georgia governor decided to draft some of the French sailors to serve as soldiers in his army, and one of the Frenchmen so honored was Lucky Pierre. Now it is possible that Pierre was pleased at the chance to prove his martial prowess, delighted at the opportunity to be a warrior. But it is also possible that he didn't particularly want to serve the king of England, seeing as how France and England tended to be at war with each other most of the time back then.

The battle for Georgia cranked up, and there was a lot of luck flying around on both sides. The Spanish ran their ships single file down a narrow channel, right past the guns of an English fort, in order to reach the harbor. By all rights the entire fleet should have been sunk, but not a single ship was lost. When a strong Spanish land force approached another English fort, Oglethorpe defied conventional military wisdom by leaving a sheltered position to charge an enemy of unknown strength. But for some reason it worked, and the Spaniards were driven back. So both the Spanish fleet and the English army were very, very lucky. But neither event had much to do with Pierre because he wasn't part of those actions. So far as we know, he didn't have anything to do with the ambush of Spanish troops at the Battle of Bloody Marsh either. But his moment was coming.

After a couple of confused days, Oglethorpe decided to finish off the enemy with a surprise attack at dawn. Lucky Pierre was placed in the front line, moving through the thick woods toward the Spanish camp.

Now the regular British soldiers were highly trained and expensive professionals, so they were not considered very expendable; officers were reluctant to take risks with them. But amateurs like Pierre could be sacrificed,

LOSING THE HOME COURT ADVANTAGE. *The Spanish Surprised.* In William C. Bryant and Sidney H. Gay, *Bryant's Popular History of the United States*, vol. 1. New York: C. Scribner's Sons, 1881–83, 163.

which is why he and the other draftees were honored with their point-of-the-spear positions. So really, what happened next was Oglethorpe's fault. If you give untrained men loaded weapons, you've got to expect that they might not use them correctly. It probably could have happened to anyone.

But it happened to Lucky Pierre. His musket was the one that discharged while they were sneaking up on the Spanish. That woke the dons up, and they rushed into position behind their earthworks. The attack wasn't going to be a surprise any longer. Oglethorpe's carefully thought out plan, the one that might have gotten him revenge for his defeat at St. Augustine, was useless now.

And Pierre had a problem. Oglethorpe and the other officers were not going to be pleased with the man who had messed up their strategy. They probably wouldn't be in the mood to even listen to explanations about "accidents," much less to understand or forgive. They were, frankly, unlikely to see the humor in the situation. Even if Pierre wasn't shot on the spot by an angry British military establishment, he could probably look forward to some truly unpleasant hours of questioning. So what should he do?

Pierre looked in front of him, where a horde of angry Spaniards were wide awake now and looking for someone to shoot. Preferably someone wearing a red coat like his. He looked behind him, where Oglethorpe would be waiting. Then he bolted for the Spanish lines.

He figured that his chances of reaching the Spanish breastworks without getting shot were better than his chances of surviving an interview with Oglethorpe. And I believe that Pierre made the right choice. But that wasn't luck. That was smarts.

So here is Pierre's situation so far. He had found himself in Georgia, probably unwillingly since it was mainly known as a refuge for convicts at that time. His ship had been trapped in the harbor because the Spanish had chosen that precise moment to avenge an attack by the English two years earlier. He had been drafted into the service of a country he didn't like. Inadvertently, he had messed up the plans of an entire army, and he had made an enemy of the most powerful man in North America. He was forced to defect, which meant that he could never get back to his ship. By this time, you might suspect I am using the nickname "Lucky Pierre" ironically. But not so. This guy was one of the luckiest people I've ever heard of.

Since the surprise was spoiled, the English called off the attack. And you might think that Pierre was lucky to be one of the few men who single-handedly altered the course of an important campaign, one that in this case helped determine who would rule the southeastern part of North America. But Pierre's actions probably didn't alter the outcome of the campaign. The Spanish governor, Montiano, had already decided that he had to give up and go back home. He had tried twice to destroy the English and had been driven back with casualties each time. The longer he stayed, the greater the chances that an English fleet would arrive from Charleston and trap him. So Georgia would have stayed English regardless of how the final clash would have turned out, had it taken place. The only thing the battle would have accomplished would have been to kill a lot of soldiers on both sides, so what Pierre's musket shot really did was to save lives. And that was certainly lucky for the men who would have died, but still not what I've got in mind.

Once Pierre was inside Spanish lines, Oglethorpe had the problem. He knew that the Frenchman would tell Montiano everything he knew about the English army and fortifications; it was too late to prevent that. So Oglethorpe needed to discredit Pierre somehow, to convince Montiano that the Frenchman was a double agent sent to confuse the Spanish. To do this, Oglethorpe arranged for a messenger to be captured with a phony letter addressed to Pierre. This letter supposedly assured Pierre that the money the

English were going to pay him had been deposited in his account. Further, the letter offered to double the money if Pierre could lead a Spanish patrol into a trap.

The Spanish governor read the letter and then thought about it. He suspected Oglethorpe was playing a trick, but he had to weigh all the possibilities. Yet did it matter whether Pierre was telling the truth? As we saw above, Montiano had already made up his mind to go home.

But Pierre's report of Oglethorpe's strength did one thing for the Spanish governor; it gave him a face-saving reason to call off the expedition. So in the end, Montiano decided to treat Lucky as a genuine defector and not a double agent.

And that's why I chose the nickname for the unknown Frenchman: I think he was really, really, really fortunate that Montiano didn't shoot him when Oglethorpe framed him.

Extreme Bird-Watching and the Fallibility of Risk-Management Specialists

When I was growing up in Florida, alligators were endangered. Today they can be summoned by a heavy dew, and you see one in every body of water large enough to float a duck. Fortunately, I like alligators, and I am glad they have made a comeback. As long as you accept them for what they are, they add interest to the state. My problem is with those people who keep trying to assure us that alligators are harmless.

When someone complains because a 'gator the size of the *Merrimac* has taken up residence in a neighborhood pond, the reassurance agents all laugh at such childish alarms and point out that alligators are frightened of people. When small dogs start disappearing, the reptilian *cognoscenti* explain that such events, while unfortunate for the dogs and their owners, bode no ill for human beings themselves. Alligators will not bother people, the experts say. Should some small child disappear, the point is made that a) after all, the child was small, and b) the child must have been teasing the creature in some reprehensible way. And if a 220-pound former linebacker is chased down the seventh fairway by a leviathan with the speed of a racehorse, a number of comforting voices will explain that the unfortunate golfer must have gotten between a mother 'gator and her young.

Now it must be conceded that the reassurance industry does good work, promptly providing plausible explanations whenever an alligator misbehaves. Were a sense of security to be found in alibis and testimonials, the experts would have done their part. Nevertheless, their efforts fail to comfort me because of one basic flaw. While the exculpatory explanations focus upon

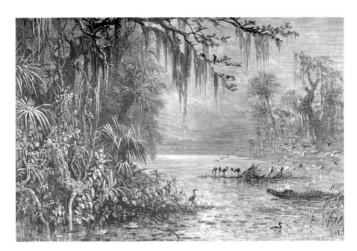

NOW IMAGINE 'GATORS BANK TO BANK. *Scene in Florida.* In William A. Crafts, *Pioneers in the Settlement of America*, vol. 1. Boston: Samuel Walker and Company, 1876, 34.

the motive or intent of the creatures, my uneasiness lies less with character than with danger.

I, for one, would be perfectly willing to admit that even the fiercest of alligators might be blessed with a sunny disposition and that its motives could be pure. Tell me that alligators are to be numbered among the benevolent, and I will nod my head in pleased if surprised agreement. I do not require additional evidence or more carefully constructed arguments to prove such points, because I am willing to grant them.

My concerns go not to motive but to diet. I don't wish to be dined upon by even the most agreeable of fauna. Nor, I hasten to add, would I be much consoled were my parts spit out upon discovery of an error. And while it is true that I do not want my children teasing animals, I believe a stern verbal rebuke is sufficient.

In truth, I have harbored a certain skepticism about the conjunction of alligators and security ever since a log I was about to step on looked at me. Now I realize that this smacks of a certain prejudice. So in support of my position, I would like to introduce the experiences of one early tourist—William Bartram.

Bartram was a noted naturalist, painter, author and traveler of the late eighteenth and early nineteenth centuries. His writings were praised by Wordsworth, Coleridge and Carlyle, his original wildlife paintings are in the British Museum and his scientific observations helped to build the discipline of botany. He was noted as an observer of birds. In his later years, he was invited by Thomas Jefferson to be the official naturalist on the Lewis and Clark expedition. It is difficult to chuck a rock in north Florida without hitting a historical marker indicating a spot where he did something or other of note.

But it is his experience with alligators that is the focus of this story.

William Bartram was one of the first people to write about the St. Johns River. In the days ere Howard Johnson, when the earth knew not Ramada Inn, Bartram determined to travel up that waterway making naturalistic observations of all he saw. And he saw plenty. Live oak trees twenty feet around, magnolias one hundred feet tall, vines a foot thick. Around one bend of the river he might see a wall of impenetrable forest, around another a panoramic view of "vast, enchanting savannas." He saw thousands of birds, thick schools of fish and gars six feet long.

He encountered hardships as well, often camping under harsh conditions. His supplies were sometimes stolen by bears or panthers. But alligators gave him his worst moments because, rather than going after his supplies, they went after him. He had to shoot some and hit others on the snout to keep them out of his boat. But he still didn't really understand the situation.

One day he found his way blocked by "incredible numbers" of alligators, some twenty feet long, crowded together from shore to shore across a narrow part of the river. Not having experts to reassure him, he quickly turned into a side creek to get away. But he was followed by two of the large beasts. They tried to jump over the gunnels of his boat, snapping their jaws near his ears. Afraid that he would be pulled from his boat or capsized at any minute, he managed to club them off and make it to the shore.

He could still hear the mass of alligators roaring in the distance. And then the sound got louder. And louder. It was at this point that he experienced a certain conflict. He had a scientist's curiosity, but he also had the memory of those two creatures stalking him. It was his duty to observe and report, yet it was possible that those twin duties were contradictory in this situation. If he observed those 'gators any closer, he might not be around to report.

At last, he dared to go back to the banks of the river to look. And there he saw a solid mass of fish trying to force their way past the phalanx of alligators waiting in the narrow part of the river. He spoke later of seeing "floods of water and blood rushing out of their mouths, and the clouds of vapor issuing from their nostrils were truly frightening." I don't know how well he slept that night, but by the next morning most of the alligators were dispersed.

Anyway, I think Bartram's experience shows us two things. First, take the experts' reassurances about alligators with a grain of salt. And second, botany is a lot more of a macho sport than many people give it credit for.

CHAPTER 14
GOVERNOR QUESADA'S AFFLICTION

Previously published in *Folio*

I picture a great banquet, at which all of the Spanish governors who once ruled Florida from St. Augustine would somehow be assembled. I would not presume to say in what clime, celestial or otherwise, such a gathering could take place. And I imagine a scene at the end of that outstanding feast—the air billowing with the non-PC smoke of fine cigars and ornate pipes, the table glittering with glasses of cognac or sherry or spiced rum—during which the governors begin to boast of the hardships they encountered when the Ancient City was new.

They would speak of plagues suffered and famine endured, of invasions repelled. They would certainly speak of pirates—of the town being burned, of raids driven off, of marauders hunted down and hanged or garroted. One governor, Ybarra, could talk of his experiences when personally captured by pirates. They might talk, perhaps with reluctance, of a time of scarcity when the town itself turned pirate, outfitting a ship to raid for supplies.

Pedro Menendez de Aviles, senior among the governors by virtue of being the first, the founder of St. Augustine, would probably let most of the others speak before he rose. Then he would quietly tell how he landed on the shores of a desolate jungle with the French fleet at his heels and then marched through swamps during a hurricane to attack an enemy fort. He would no doubt sit down, take a sip from his brandy and allow the others to appreciate his words. Game, set and—

That's when Governor Juan Nepomuceno de Quesada would leap to his feet and shout: "Amateurs!"

Governor Enrique White would also rise: "Dilettantes! Slackers!"

Then together the two Excellencies would glare around the room and demand: "Did any of you ever have to deal with Jorge Biassou?"

For Governor Quesada, the first warning came with the arrival of a new *caudillo*, or general, transferred from the Caribbean theater in 1796. The governor had thoughtfully provided lodging for the high-ranking officer, Jorge Biassou, and his family. Quesada even sent over supper for two nights. In lieu of a thank-you note, Biassou complained that he had not been asked to dine at the governor's own table. It is probably just as well that the governor's initial reply has not been preserved. Given command of Fort Matanzas, which guarded the back entrance to St. Augustine, Biassou complained that it was a step down from his former commands.

Now, there are those whose excessive meekness offends; they drive you crazy because they never let you know what they're unhappy about. Jorge Biassou never, at any time, resembled one of these people. The governor would later remark, with a stiff upper lip and Spanish understatement, "it is a great problem to decide how to deal with him."

Money was the most usual cause of contention between Biassou and the governor, even though Biassou's stipend was a princely 3,000 pesos per year. The salary was impressive, but the really remarkable thing was that it was actually paid. Very few military types in St. Augustine were ever given what they were owed. But a 3K income was nowhere near good enough for Biassou. He believed he was supposed to get 3,840 pesos per year, very close to the governor's own stipend. When the governor was paid. And Biassou wasn't going to settle for a peso less. He also requested money to buy a house, since he certainly couldn't be expected to pay rent with his meager salary. And besides, his brother-in-law was living with him.

Not only did Biassou continue to complain to Governor Quesada, and in later years to Governor White, but he also went over the governors' heads to the captain general of Cuba. It could have been worse. When Biassou lived in Santo Domingo, he tried to get the captain general of that island dismissed.

In all of these appeals, Biassou was handicapped somewhat by the fact that he neither spoke nor wrote Spanish and required interpreters. Preferably paid for by the government.

Now you might wonder why Governor Quesada, and later Governor White, put up with Biassou for so long; after all, the governor of a frontier province has

BIASSOU MIGHT HAVE COMPLAINED A LITTLE. Jorge Biassou commanded Fort Matanzas during his St. Augustine stay but saw it as a comedown from his previous assignments. Built to guard the "back entrance" to St. Augustine, the fort is located near the scene of the 1565 massacre of the French. *Author's collection.*

considerable power and autonomy. But Biassou was what the Spanish in the eighteenth century called a *"honcho grande"* or *"el Dude y Don Wanna Mess Wit."*

When France declared war on Spain in 1793, Biassou led an army of auxiliaries for King Carlos IV. They fought so well that Biassou was given a gold medal by the monarch, along with documents expressing the gratitude and confidence of the Spanish government. Relatively few people in the empire, never mind St. Augustine, ever received such honors. To critique Biassou too openly was to risk appearing to cast doubt on His Majesty's judgment and was a really bad career move.

Yet he was undeniably a problem. In addition to that personality that some people perceived as less than soothing, Biassou created trouble just by being who and what he was.

The racial situation in Florida was complicated by the time Biassou arrived. There were Italians, Greeks, Minorcans and British settlers in St. Augustine, but blacks posed a special problem. While some of these were slaves, many were free. Spanish law allowed for self-purchase, and Spanish policy promised

liberty to slaves who fled British owners for Florida. In the really old days, the Freedom Road ran south. The Spanish could be as prejudiced as anybody, but they had found they needed black help in both civilian and military life. Blacks manned Fort Mose as a forward outpost north of St. Augustine, and their martial efforts had proved crucial in stopping Oglethorpe's invasion in the mid-1700s. A black man had led a successful defense against a group of American marines during the Patriot Rebellion (don't ask). The Spanish government had to somehow attract the blacks from the British colonies and ensure their loyalty without unduly alarming Spanish slaveholders.

And into this delicate balance came an exalted and gentle *caudillo* named Jorge Biassou. Did I mention he was black?

He had earned his rank and his honors fighting white professional soldiers during a slave rebellion in Haiti. This former slave, who had risen to a higher rank than most people in St. Augustine and who had been honored by the king, was anything but low profile. On the contrary, he was willing to challenge the highest authorities. On anything.

Slave owners feared he would set a bad example, this black commander who had fought successfully against whites. He certainly set a bad example for other former black auxiliaries, who were inspired to protest their own reduced incomes in St. Augustine. The effects of Biassou's stormy presence upon native blacks is not recorded, but it was the subject of fearful speculation.

Still, if Biassou was sometimes a burden to deal with, he was at least a good general. It would be reasonable to suppose that in time of war he could earn his keep. And in the early 1800s, he had his chance. The Seminoles and Lower Creeks began a series of raids, so Biassou was given command of a militia unit. He probably would have done great things, justifying all of the trouble he had caused.

If he hadn't chosen that moment to get sick and die.

After Biassou's death, St. Augustine's pride in having a celebrity apparently won out over racial bias. He was buried with full military honors—tolling bells, candles and incense, an honor guard discharging volleys. Mind you, the authorities later melted down his gold medal to help pay his debts. His widow—continuing his legacy—feuded for years with the Spanish government over the size of her pension.

Well, I imagine the august company of governors would soon move on to other reminisces, perhaps of past banquets, or of sights seen, or adventures in other lands. But I suspect that no one would dare challenge the calamity-enduring credentials of Governors Quesada and White, who had to deal with Jorge Biassou, the black *caudillo* from hell.

Ralph Waldo Emerson, Martin Luther King Jr. and the Barking Methodists

Previously published in *Folio*

Ralph Waldo Emerson was not prejudiced; some of his best friends were Methodists. He even based his first sermon on a conversation with a Methodist, so it would be unfair to say that he was biased against folks of that persuasion. What was true was that he held certain reservations about the Methodists he met when he was snow-birding in St. Augustine one winter. But he would have said that he had his reasons.

He had heard, for instance, a story about a group of Methodists who were jumping up and down on all fours, barking like dogs and pretending to have treed Jesus. Now he was aware that this report was only hearsay, and he understood such behavior was not part of the typical Methodist order of worship. Even if the report concerning those particular Methodists were true, he was pretty sure that they eventually got Jesus down from the tree. But there is no doubt that Emerson found the report vaguely troubling. The more he thought about it, the more it seemed to him that such behavior was not the New England way.

Also, he had his own firsthand observations. When he attended services at the Bible Society, a Methodist-influenced group offering the only Protestant services in town, he heard a lot of swearing and saw at least one fight. Again, this was not the New England way. He perceived Reverend John L. Jerry, the Methodist minister who frequently ran the meetings, as unmannerly— certainly the man should have maintained better order. Emerson said it

more transcendentally, but he basically implied that the Methodists of St. Augustine lacked a certain couth.

Emerson wasn't the only person to have a problem with St. Augustine Methodists, or even with the Reverend Jerry. One Catholic priest was offended because Jerry was going from door to door talking about religion and passing out tracts. The priest tried to forbid the preacher from doing that, but the reverend simply pointed to the American flag flying from the fort and kept knocking on doors. Once again, the Methodists seemed to lack a certain refinement.

Then there were the plantation owners. Out of the fifty-two members of the first Methodist congregation in St. Augustine, forty were black. What kind of example did that set? Even worse, those Methodists were notorious for opposing slavery.

But that peculiar antislavery preoccupation of the Methodists was one that Emerson was starting to share by the time he left Florida. On his trip south, he had discovered that slaves were people. In Charleston, he was astonished to see blacks, both free and slave, greeting one another just as whites did. And in St. Augustine, while he was sitting in services one day, he became aware that a slave auction was taking place right outside. As the scripture was read, he could hear "four children without their mother" being sold. His later abolitionist stance may well have originated in that experience. I suppose it may be worth noting that the people buying and selling children were not the ones sitting in the service.

Anyway, at the end of the winter, Emerson set out for the more genteel pulpits of New England and eventually made his literary fortune.

The Reverend Jerry and the Methodist circuit riders who followed him set out for the deep woods. They got lost, almost drowned in rivers, starved and mostly died young. They ministered to soldiers at remote forts, to settlers in cabins, to slaves on plantations, to Seminole villages and to towns of free or runaway blacks. Even during the Second Seminole War, as massacres occurred all around the countryside, John Jerry was still going from post to post preaching the gospel. They might have been a little short of couth, but them old-time Methodist preachers went where they were needed.

Well, times change. The Methodist preachers remained antislavery for a long time, but they had to tone down any abolitionist talk or the plantation owners wouldn't let them speak to the slaves. The circuit riders finally settled down into parsonages and ministered to one town at a time. They began to feel that they had to fit in with their parishioners. The whole denomination gradually turned middle class and respectable. Which meant that blacks

MIND YOU, THE AUCTIONEERS WEREN'T THE ONES SITTING IN CHURCH. Old market in St. Augustine; possible site of slave auction overheard by Emerson while sitting in worship service. *Author's collection.*

were no longer treated as equals but instead were forced to sit in the back of the church, or in the balcony.

So, growing tired of this second-class status, they left. That initial Methodist congregation in St. Augustine split into two churches, one black and one white. Along the way, Methodists of all colors picked up a lot of couth; today they rarely go from door to door passing out tracts.

Times change, and they keep changing. In the 1960s, the civil rights movement came to St. Augustine when local blacks demanded integration and fair treatment. The movement met with a lot of resistance from whites: angry crowds screamed, the police set dogs on demonstrators and acid was dumped into a swimming pool when blacks tried to use it. Eventually, Dr. Martin Luther King Jr. was called in to help.

And one day, Dr. King showed up at the white branch of that Methodist church that descended from the original integrated congregation—the branch that had already turned away blacks who tried to worship there during the demonstrations. But the members of the congregation had some qualms. They talked about the possibility of a visit by King and did

a lot of soul searching. On the one hand, they were southern, raised to see segregation as natural. They would lose a certain amount of respectability in the eyes of their neighbors if they allowed blacks into their church. And dang it, they didn't like being pressured, especially by Yankees. On the other hand, it was the house of God and should be open to all.

They resolved to invite Dr. King to attend their worship service, but only if he came as an individual and not at the head of a publicity-oriented demonstration. That seemed to many in the congregation to be a reasonable compromise. But of course it didn't suit the needs of Martin Luther King, who was trying to destroy the evil of segregation across the land. He needed either a public welcome or a public confrontation. A lot of publicity was generated by the St. Augustine campaign, and many people credit it with helping to pass the Civil Rights Bill of 1964.

Now a case can be made that the congregation acted as well as it could under the circumstances, opening the church to private worship by Dr. King at a time when white society was violently opposed to any act of integration. And a case can be made that a great opportunity was missed by those in the church, because they could have publicly opposed segregation just as their ancestors had publicly opposed slavery. Christians are warned not to be conformed to the world. That church eventually repented of its actions during the civil rights struggle and, years later, held a service of reconciliation in which the congregation apologized to local blacks.

But it is a flat shame that Emerson's Methodists weren't still around in the 1960s. Had King knocked on their door, those uncouth fellows would probably have dragged the good doctor inside and had him barking on all fours before the morning was out.

A Dream of Pyramids

They marched through pine and palmetto. A lot of it. They had marched all the way from Fort Brooke, near Tampa Bay, and they still had to march all the way to Fort King, a few miles south of Paynes Prairie and the new town of Micanopy. Christmas had given them a good excuse for celebrating three days ago, but it was back to work now. Had 'em a couple of horses that enlisted men didn't get to ride, and had 'em a cannon they had to drag along what passed for a road in these parts. Always lots of fun in the army. They marched through all that pine and palmetto and never saw the men who ran from one clump of foliage to another.

Their conversation, if we could have heard it, might have gone something like this.

"I been dreaming about pyramids, Egyptian pyramids, for three nights running. What you reckon that means?"

"I 'spect what it means is, you don't have enough to do if you got time to remember dreams and such." That was Samuel Giddens. They didn't pay him no mind, since Samuel was that way about most everything.

"No," said Percy Browne, "I figure we ought to take this seriously, since he done dreamed about it three times. This here is kinda Biblical, and we are probably supposed to interpret a dream what has multiple occurrences."

Samuel just spat.

There were 108 soldiers marching through all that pine and palmetto, and none of them really knew why. They had heard something about Indian trouble, but there was always Indian trouble in Florida these days, ever

since the government said they were going to have to move out west to the territories. Seemed to irritate the Indians even more than usual, and they had always been a bit on the sullen side. So the soldiers kind of figured they were being sent somewhere or other to try to keep the lid on.

But most of them didn't know anything about the Spring Grove Guard shooting up a bunch of Indians who had gotten off the reservation a few miles north of Newnansville back in June. And they sure didn't know anything about what happened up in Fort King way back in May. Seems a bunch of white people had locked up the wife of an Indian named Osceola because she was descended from a runaway slave. A lot of those Seminoles were black. But anyway, an Indian agent by the name of Thompson had thrown young Osceola himself into the stockade when he objected to the way they treated his wife. Of course, the agent later turned Osceola loose and gave him a new rifle, trying to make up.

It wouldn't have mattered much to the soldiers if they had known, because they had been way down in Fort Brooke when it all happened. Didn't seem like something that took place that far away could have much to do with them.

So they talked about Waller's pyramids. Percy allowed as how pyramids were associated with the wealth of the Egyptian pharaohs, so he figured that it meant Waller was coming into some money. But Jimson said that pyramids were associated with mystery and magic, and he thought that maybe Waller ought to be paying more attention to his spiritual side. Samuel said that if they were going to go all Biblical and prophetic, they ought to go for the real thing and store up grain for seven years, like Joseph told Pharaoh in the Old Testament.

They kept marching toward Fort King as they talked, through all those pines and palmettos. They had no way of knowing that, as they marched, Osceola was hiding outside the stockade waiting for Agent Thompson. Waiting to use that new rifle Thompson had given him. Waiting to show how grateful he was for the whole experience. But all this was quite a few miles away. What was more relevant to the soldiers' present situation was Micanopy—the chief, not the town—skulking among those palmettos with about one hundred soldiers.

Percy had reconsidered about those pyramids, and he allowed as to how he now thought the important thing about pyramids was that they were old. So he now figured that the dreams meant Waller's future girlfriend was going to be a bit long in the tooth. Waller was begging to disagree with that particular interpretation when they shot Major Dade. The Second Seminole War was cranking up pretty good by now.

"With the Whole World and All Those Woods Around Them, They Chose to Pen Themselves Up in a Little Box." Reconstruction of defensive structure thrown together by Dade's men, Dade Battlefield Historic State Park. *Author's collection.*

Samuel, Percy, Jimson and half of the other soldiers were killed right after the major. The survivors, including Waller, fired back as best they could and chased the Indians back for a spell. Then they built themselves a triangular barricade out of pine logs and got in it. They miscalculated a bit and made it too small, so the cannon had to be left out in the open. The Indians came back.

Later on, one of the braves who had been at the battle commented that Micanopy and his men had never expected to do more than take a few pot shots at the soldiers. But when they saw the troops were just sticking around like poultry in a cage, they figured they had themselves an opportunity.

"With the whole world and all those woods around them," the brave said, "they chose to pen themselves up in a little box."

At first a few soldiers were willing to man the cannon sitting outside the barricade. But after the shooting got heavy again, no one would set foot outside the log structure, which was not built well enough or high enough to keep the Seminoles hiding in the woods from shooting them down one after

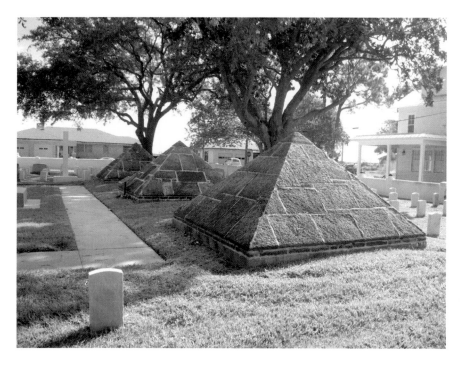

THE END OF THE MARCH. Pyramid monuments for Major Dade and his men, National Cemetery, St. Augustine. *Author's collection.*

another. In the end, only three soldiers survived the massacre. Robert Waller was not one of them.

About two months later, General Gaines marched along the same route and found the battlefield. He buried Waller and Major Dade and the others as best he could. Still later, people from St. Augustine came and got those remains. They reburied the men killed in the Dade massacre with full military honors in a national cemetery. And eventually, over the graves, they raised up three coquina pyramids.

HOGTOWN CHANGES ITS NAME

In 1853, the citizens of Alachua County decided that the name "Hogtown" was going to have to go. They had just learned that the new railroad would not pass through the present county seat of Newnansville but rather through a little hamlet—so to speak—to the north. That meant that they were going to have to move the county government, and that meant that a name change was going to be in order.

It was not that there was anything intrinsically wrong with the name "Hogtown." Certainly there was no wish to denigrate swine or those hardworking voters who raised them. Even the most orthodox of crackers could accept the name "Hogtown" in good conscience.

No, the problem lay not so much with substance as with image. While the name "Hogtown" was quite adequate for a village, it seemed to lack a certain *dignitas* when used for the central urban area of an entire county. If you wished to impress potential investors with the cosmopolitan character of your community, "Hogtown" might not be your first choice of appellations.

But what to call the city, if the name hallowed by tradition were to be abandoned? One might, of course, simply coin a name with more desirable connotations—"Gloryburg," "Prosperityville" or "Bumpercrop" spring to mind as possible candidates. Alternately, one might prefer a name that could summon its citizens to virtue—"Frugalton" or "Gumption," perhaps. But such names do not always wear well in the long run. They sometimes turn out to have a certain self-congratulatory air or, worse, tempt fate—like calling a ship "The Unsinkable."

The solution adopted by many towns in this situation was to name the place after a famous figure with ties to the area. And for Alachua County, the natural pool from which to draw a namesake would be Seminole War celebrities. The wars had swirled across the county, and a number of heroes had arisen during the conflict.

There was Colonel Newnan, who had fought the Seminoles of Alachua County way back in 1812, long before Indian fighting was cool in this part of the country. But there were formidable arguments against using his name. First, he had lost. A second and more serious drawback was that the old county seat, Newnansville, was already named for the colonel. While it was theoretically possible that its inhabitants could be persuaded to swap names with Hogtown, they were frankly a little miffed at their loss of status and therefore most likely not open to such a suggestion. In any case, it was unnecessary to go to so much trouble.

Because there was a perfectly good general to name the town after, one who had been commander of the Western Division at the start of the Second Seminole War. A general whose name was not currently being used in a real estate context. And not just a fight-from-headquarters general, but one who had insisted upon hands-on involvement.

Now the general had encountered one problem. Before he could mix it up with the Native American types, he had to disobey an order. Washington had commanded him to go to the western frontier, where there was apparently some sort of political disturbance. And, of course, soldiers are trained to follow the orders of their superiors. Still, officers in the field often have a better feel for the real-life situation than those back in the capitol. The general knew what the higher-ups might not have realized: the Second Seminole War was getting started in earnest, and it was going to be big. As it turned out, it would be the biggest and longest lasting of all the Indian wars. The general chose the Florida conflict over the Texan one.

He marched his troops from the Tampa Bay area to Fort King, just south of Alachua County. And along the way he came upon an awful sight— the remnants of a log barricade, with the bodies of dead soldiers scattered everywhere. He knew that this had to be the scene where Major Dade and all but three of his men had been massacred in an ambush two months before. The general paused to bury the fallen soldiers and then marched on, more eager than ever to fight Seminoles.

But where to find the foe? He heard that another general, General Clinch, had recently been ambushed and defeated on the banks of the Withlacoochee River. Perhaps the enemy continued to lurk in the area. So, in February 1836,

the commander of the Western Division left Fort King and marched to the Withlacoochee. And sure enough, the Seminoles were still there. Like Clinch, and Dade before him, this general was also ambushed. He promptly adopted the strategy used by the soldiers in the Dade Massacre and built a log barricade to enclose his troops. The general and his troops were pinned down by the Seminoles for eight days, until they were finally rescued by still another army and made their escape.

So in a matter of months, the general had gotten the personal involvement he wanted and made his contribution to the war. By adopting the tactics of two defeated armies, he had very nearly duplicated their lack

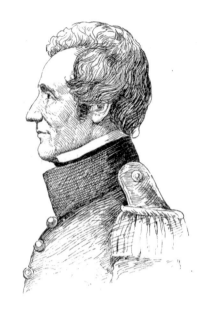

HOGTOWN HERO. *Portrait of General Gaines*. In *Appleton's Encyclopedia of American Bibliography*, vol. 2, edited by James Grant Wilson and John Fiske. New York: D. Appleton and Co., 1886, 572.

of success. By August 1836, central Florida was devoid of whites, and the Seminoles could freely roam Alachua County, an area that was to someday include a little cluster of houses called Hogtown.

Naturally enough, it was this great general who was chosen as a namesake for the town.

But what if the general had taken the other path that lay before him in 1835? What if he had followed orders and gone to the western frontier? He probably would have found himself in another siege, which strangely enough took place on the same dates as his Florida battle. But rather than being trapped on the banks of the Withlacoochee River by Seminoles, he would probably have found himself trapped by Santa Anna's army in an old mission called the Alamo. People's roads to destiny are forked by choices, but perhaps there are those for whom all paths lead to glory.

Still, he chose Florida over Texas, and so it was his name that Hogtown adopted. As it turned out, the name proved a prophetic one. General Edmund Pendleton Gaines was always eager to fight the Seminoles. And even today, the inhabitants of Gainesville still love to fight the Seminoles of Tallahassee.

CHAPTER 18
GOTTA GET A RECEIPT

O K, now these may not be the precise quotes, but this is basically what happened.

On January 7, 1861, the local Florida militia, soon to be a Confederate militia, was ordered to occupy Fort Marion—aka the Castillo de San Marcos, aka "Would you look at the size of that thing?" So the 125 soldiers marched up and told the old sergeant who served as caretaker that they were taking over the fort.

"No, you ain't."

"Excuse me?"

The caretaker was the only soldier stationed at the fort. "This here's gumment property. I can't turn it over to just anybody. You gonna have to show me some paperwork."

The militiamen retreated to talk over the situation. Now, with the imbalance in forces, their problem was not strictly speaking a military one. Like one of them said: "We could just shoot the old buzzard when he sticks his head over the rampart to look around."

The question wasn't whether they could take over the fort; the question was whether they could do it without anyone getting hurt.

"Some of us know Sarge. We don't want to kill him."

Also, there were other considerations. They weren't officially at war with anyone yet. Besides, if everyone who wanted to shoot a sergeant was allowed to do so, chaos could reign.

Consequently, they sent a delegation to see the Union man to persuade him that he should surrender the place to them. The commander did most of the talking on the militia side. The sergeant spoke for himself.

"I can't just turn the place over; I'm responsible for it."

"Try to see it from our point of view. On one side, we have 125 men. On the other side, you have you."

"Ain't got them papers, though, have you?"

The commander rubbed his forehead. "Sergeant—"

"This here's a fort, you can't just walk in. It's got walls over 13 feet thick. It's made of soft coquina stone. Cannonballs just get stuck in it."

"That's not an advantage anymore. They've got rifled shells these days that will burrow into that stone and explode. One modern gunboat could take this old fort apart in a matter of hours."

"How many of them modern gunboats you got, sonny?"

The commander snatched his own hat off his head and then calmed himself. "All right, Sarge. That's a valid point. But we can get some of those new cannon here in a few days, and they will do the same thing the gunboats would."

"This here fort has stood the test of time. It stopped the pirate raids. The British tried to take it in seventeen-ought-two and again back in the forties. That'd be the seventeen forties. They had armies and everything, and they couldn't do it. All you've got is 125 militiamen."

"Now Sarge, those Spanish defenders also had armies. And at the risk of repetition, this brings us back to your main weakness. You have no army."

"Let me tell you something. These walls are over twenty feet high, and the place is surrounded by a moat. How you gonna get past all that?"

"That moat is six inches deep at best. What you have in there are catfish and crabs, which I don't think are going to keep away men with boots. And there is a new-fangled invention called a 'ladder' that is pretty helpful in getting up walls."

Sarge tried to speak, but the commander continued.

"Now it is true that if you had enough men, they could hurl our ladders to the ground as fast as they were placed, or maybe dump boiling oil on us. But if you had those men you wouldn't need boiling oil, because they could just shoot anyone who got too close. I do hate to go on about this, but your problem lies precisely in the fact that you lack those personnel."

The old man seemed to be thinking it over, so the militiaman kept talking.

"Rest assured, your valor is not at question here. But while your defense of the drawbridge on the southern side of the fort might prove to be both noble and effective, the northern side would be undefended. Or should you

decide to station yourself in the northwest bastion, the southeast bastion would become vulnerable."

And at last, the sergeant wavered. "All right, then. Now supposing—just supposing, because I ain't making any promises yet—supposing I was to turn over the keys, I'd have me two conditions."

"Which are…?"

"First, it would have to be made clear that I'd be turning this place over under protest."

"Sarge, you have established that point admirably. Should someone unjustly accuse you of embracing this turn of events, I for one would be willing to testify to the contrary. What is your second condition?"

"I gotta get a receipt."

And he got one.

THE YEAR WITHOUT TOURISTS

St. Augustine has always had a love-hate relationship with its tourists. I think it started way back in Spanish times, when people from UpNorth kept dropping by—people with red coats, from South Carolina in 1702 and from Georgia in the 1740s. Those folks just trashed the place—burned the town, tried to shoot holes in the fort, all kinds of things. After the United States became a country, but during the time that Florida was still Spanish, Americans kept coming down and stirring up the Seminoles. So you can see where folks would get to the point where they didn't much care for northern visitors.

But once Florida became part of the United States, a lot of the townspeople were tourists. Or at least people from UpNorth who had moved to the territory once the United States took over. Of course, once they lived in town for a while, they became St. Augustinians. And Floridians. And southerners. Then they started poking fun at the newer people from UpNorth, people like Ralph Waldo Emerson, who would come for a winter visit. Snowbirds.

Mind you, it was nice in a lot of ways to have the visitors. Kinda fun to see new faces, talk to people who knew things about other parts of the country. And you had to admit that they did bring money, and they did spend it. On the other hand, there were a few drawbacks. They didn't know how to drive properly, so they were a menace if they ever got hold of a horse and carriage. They'd ride around for blocks with their arm stuck out in a left turn signal. Worse, they kept talking about the way they did things back home, which a lot of times was different than the way they did things in St. Augustine. And of course by "different," they meant "better." So in those far, distant days, so

DRILL, BABY, DRILL. Troops drawn up in plaza as shown in *Frank Leslie's Illustrated Newspaper*, December 13, 1862. After the Blues left and St. Augustine was occupied by the United States, Union troops also used the plaza for drilling. *El Escribano* 23 (1986): 71.

hard for us to understand, St. Augustine had an ambivalent attitude toward its tourists.

But there was one year when St. Augustine found out what it was like to live without visitors from UpNorth. It was the year without tourists.

It started as the country drifted toward war, even before Florida seceded from the Union. The tourists from UpNorth just didn't seem as enthusiastic about secession as the locals were; those different viewpoints that the northern visitors had were starting to matter.

As the situation heated up, the townspeople figured they'd better prepare for trouble. So they revived an old Seminole War outfit called the St. Augustine Blues. This was a small group of volunteers—seventy-nine men at first—but an interesting one. Four were black—might have been the largest group of regularly enlisted blacks in the Confederate army until the very end, when the Confederacy got desperate. Fourteen of the men were over fifty years old. And sixteen were under seventeen—including one boy named Bartolo Genovar.

The Blues tried to get the governor to authorize funds for weapons, but he wouldn't spring for the expense. That meant they had to make do with a bunch of antiques. The women of the town did fix them up with some uniforms, though, and a flag with three cotton bolls on a blue field.

The little girls of the town, including a nine-year-old girl called Mary Louise Gomez, probably watched the boys and men drill.

Anyway, as the winter of 1861 settled in, not as many visitors came down. Some of the ones who did come down were a little quicker to leave. And, truth to tell, a lot of the locals were getting a little leery of the northern visitors among them. Was it possible that they might provide intelligence to the Yankee enemy, if worse came to worst? Maybe do more than that? So there were some rude things said in the local paper, and even more northerners left.

The year without tourists had begun.

Well, the soon-to-be-Confederates took over the old fort, the one the Spanish called the Castillo de San Marcos but which was now called "Fort Marion." And the town was pretty glad, because there was a lot of southern patriotism. A new flagpole had been erected, and a series of Florida and Confederate flags was flown from it. A man named Kirby Smith came to town to get married before leaving for his Confederate general gig.

But the local military didn't have much more than a shell of a fort. The new government was more worried about other theaters of the war, so it took almost all of the cannon from the local fort and shipped them off to Fort Clinch up in Fernandina and to parts even farther north. Without cannon, artillerymen were pretty useless, so they got shipped off to other places too. That pretty well left the Blues.

The thing was, St. Augustine was still the Rodney Dangerfield of military theaters, as it had been in colonial times. Neither side thought that the place was very important. Certainly not its fort—gunboats with rifled cannon had already leveled stone fortifications up and down the coast. The commander of the Department of South Carolina, Georgia and Florida—a fellow named Robert E. Lee, who was to get a promotion later on—said that the small number of troops in St. Augustine only served as an invitation for the enemy to attack. A Union guy named George McClelland offered the opinion that "St. Augustine might be worth taking by way of an interlude." An interlude! No respect.

Well, the Year Without Tourists was really cranking up now. It probably seemed like a dream come true to some of the locals. But then they began to notice that the Yankees had taken their money with them when they left. Between that and the fact that a lot of the local men were away at war, the town wasn't collecting nearly as many taxes as it usually did. The city government proposed that businesses be asked to pay more taxes, but the businesses said that they couldn't. They just weren't selling as many goods without the usual northerners spending cash.

So, by early 1862, the town had to cut back on basic services. The support for paupers was eliminated, and local churches were pleading for help to take

up the slack. Even the town scavenger was put on indefinite leave. Between the missing tourists and the tightening Union blockade, the town was sinking into starvation. Residents were living on the same subsistence diets that the first Spanish had eaten three hundred years earlier.

Thus it was that St. Augustinians had mixed feelings when, after several false alarms, the first Federal scouting vessels were spotted off the coast in March 1862.

The Blues left town on the night of March 10, about fourteen months after the Confederates had taken over the fort. The townspeople, including a now ten-year-old girl named Mary Louise Gomez, watched the Blues march out of town; they knew they wouldn't be seeing many southern soldiers for a while. As Mary Louise waved at the neighbor boys marching away, she might have paid particular attention to young Bartolo Genovar.

Now a lot of people will tell you that St. Augustine was Union throughout the War of Northern Aggression. But for more than a year, 1861 and a bit of '62, it was Confederate. That ended on March 11, when Union gunboats appeared outside the harbor. Acting mayor Christobol Bravo, stuck with the unpleasant job of turning the city over to the enemy, ran up a white flag over the fort. He met with Commander C.R.P. Rodgers of the frigate *Wabash* on the town pier, and the two of them walked over to city hall, where a town meeting was in progress, to complete the surrender procedure. Rodgers ordered Bravo to hoist a Union flag, but this was a little difficult. The women in the town had chopped down the flagpole in the plaza and cut it up for souvenirs. Bravo had to go to the now-empty fort to find a pole to raise the Stars and Stripes. Still, the thing was finally done.

The Yankee tourists had come back.

<center>***</center>

When the Blues left St. Augustine, they went to New Smyrna first. They didn't get to stay in Florida though, but ended up joining the Army of the Tennessee out in the west of the Confederacy. That was hard duty, and dangerous. Out of the 120 men who served in the Blues, only 8 were still alive when they mustered out in 1865. Among the survivors was no-longer-sixteen-year-old Bartolo Genovar. One of the youngest recruits, he lived to be one of the oldest veterans at age ninety-eight.

Bartolo came back from the war with nothing in his pockets, but he went on to become wealthy and used his wealth for the community. He built an opera house for St. Augustine, because he believed culture made people happy. He had a farm west of town, and he later named the area "Elkton" because he belonged to the Elks club.

And in 1872, he married Mary Louise Gomez, the little girl who had watched him march out of town ten years earlier. Many years later, the youngest recruit and his bride were celebrated for having been married longer than anyone else in St. Augustine.

JOHN, ROSEDA AND POLLY

A Cracker Family

John, Roseda and their daughter Polly lived in Istachatta, Florida. So did Dot and Johnnie, Polly's younger sisters, but this story is not about them. John was about twenty-five years older than Roseda. Years later, when people would ask her why she had married a man so much older, she would pull out a picture of him taken about the time they married. The women seemed to think the picture made it obvious. Now if you are not familiar with Istachatta…well, it's between Pineola and Nobleton. Actually, John and Roseda didn't live in Istachatta proper. Their farm was in the middle of the woods, and it wasn't near much of anything. Greater metropolitan area, I suppose you could say.

One of the reasons that John and Roseda lived in such a remote area was because of their oldest daughter. Polly was severely mentally challenged. The "experts" of the time wanted them to put her in a special institution, but John and Roseda refused. They believed that family looked after family. Years later, the experts changed their minds; they had found out that mentally challenged people did a lot better at home than in institutions. So I guess you could say that John and Roseda were kind of avant-garde for that era.

What they did do, though, was to stay on that farm out in the woods, even in later years when it might have been a lot easier on them if they had lived in town. They were afraid that people would poke fun at Polly if they went to a place big enough to have folks who didn't know her. John and Roseda never went into a restaurant with Polly or took her into stores. In the "good old days," if you didn't get rid of your peculiar family members you were expected to keep them out of sight.

Well, except at church. Roseda always insisted on taking Polly to services with her. The people at New Hope Methodist were expected to understand, because it was God's house. And they did. But Roseda felt uncomfortable taking Polly anywhere outside the local community. Now John would take Polly with him to town or anywhere else. She might stay in the car, but she got to go for a ride, and she got a candy bar or something. He had a reputation for being a bit on the misanthropic side, but he made an exception for Polly.

John did a lot of things to earn a living, but mostly he ran a small sawmill. He was apparently an independent, self-reliant type. He would slaughter his own hogs and make his own sausage. He built his own house, cut his own lumber and made most of the fixtures in his own blacksmith shop. He was old-fashioned about a lot of things, even for his day. He was still plowing with oxen one hundred years after most people had switched over to mules. I guess he didn't see mules as a significant improvement. But once he decided that tractors were better than either mules or oxen, he built himself one in his blacksmith shop. A tractor, I mean. He wouldn't go inside the little Methodist church very often, although he did a lot of free work for them when nobody was around.

When he was dying, John worried about who was going to look after Polly. He also worried about who was going to run the farm. Well, Roseda did; she took care of Polly and the farm all by herself. About five feet tall, she chopped wood, mended fences and turned gardening into an art form. She pumped water and trimmed oil lamps until she finally got running water and electricity. She and Polly basically lived in the 1800s until the middle of the 1950s.

Roseda managed to earn a living from a small dairy farm. She learned how to woman-handle those big cows when she needed to. If one got screwworms, she would somehow throw the animal on the ground, take tweezers and actually screw those ugly things out. She milked those cows twice a day, churned the butter and sold the dairy products to people in the little community. Later, when she was more prosperous, she would hire cowboys to help when she had extra work.

Roseda did what she needed to do. And she took Polly with her on the milk runs. Polly always loved to go for a ride, and Roseda would always get her some candy at the general store on the way home. Sometimes Roseda would take Polly over to Brooksville for fried fish and a picnic or drive up to Inverness so that Polly could look at Christmas lights.

But after some years passed, it was Roseda's turn to worry about what was going to become of Polly. It became more difficult for the two of them

LOOKED A LOT BETTER WHEN JOHN WAS AROUND. Home of John, Roseda and Polly. *Author's collection.*

to stay on the farm as they got older and frailer. Roseda still didn't want to relocate to a town, because she didn't want Polly to have to deal with the unkindness of other people. But the day finally came when she had to move into a nursing home, so she took Polly with her.

And Polly loved it. The other residents showered Polly with attention and enjoyed looking after her. It turned out that Polly had been lonely during all of those years when the family had been isolated on the farm. Later, after Roseda died, Polly stayed in the nursing home. Polly's younger sisters would take Polly for rides sometimes. Usually they'd just drive her around town, maybe look at Christmas lights. But one day they drove her out to the old farm. And Polly became agitated, made it clear that she wanted to go back to the nursing home.

Polly is still in a nursing home in St. Augustine. She is confined to a wheelchair now and is blind. She still loves fried fish and picnics, although the picnics are on the grounds. And she still likes to go for rides, although the rides are wheelchair rides now and go no farther than the parking lot. She likes the bumps in the rough pavement.

CHAPTER 21
THE PICTURE

What do you see when you look at a photograph? How does that change as you learn more about the story behind the picture? One of my favorite photographs is a copy of one that hangs in a museum. The original has won prizes, although that is not why it is a favorite of mine. The photograph is a black-and-white picture that has been hand-tinted, and it looks antique. It shows an elderly lady polishing the glass chimney of a hurricane lamp with a piece of cloth. She sits before a window. Dark walls, dimly lit furniture and some bright flowers surround her.

Looking at the photograph itself, knowing nothing else, you might feel nostalgia for a simpler time than our own.

The lady in the picture could have told you more—the picture is, in a sense, a fake, not old at all, but taken fairly recently. Although the woman really had performed the lamp-cleaning task many times, back in the days when oil was used to light the sanctuary, she posed for the picture long after electricity had arrived. The photographer had deliberately used an old-fashioned process to give an appearance of age.

She used to point out that old-timers could tell the picture was staged because she is using cloth to clean the glass. Lamps would have been cleaned with Spanish moss back then, and small scraps of cloth would have been saved for patches or quilts. Even feedbags were recycled into clothes, and many had patterns printed on them for this purpose.

So with a little more knowledge, you might still be reminded of the past—but a past of hard times and poverty, a time when you dared not waste anything.

But there is other information that the lady in the picture does not know herself. The window she sits before in the photograph overlooks a cemetery and her husband's grave. What she is unaware of is that she will lie beside him before the year is out, and that this trip to the church is the last time she will leave her house until she goes into a nursing home.

So knowing this much, you might not see the past at all, but rather a hard present and a bleak future.

Yet there is still something to be learned. The little church the woman sits in almost perished. She and five other elderly members were the only reliable congregation for many years. Perhaps foolishly, these six elderly people worked to keep the church doors open when younger folks moved away from the little community to seek a living wage. The six of them did the maintenance and repairs. They raised money to keep a modern circuit-rider pastor coming. They helped out the needy in the community. Each Christmas they arranged to have a pageant performed and gave small gifts to those children who still lived in the area. Year after year they endured, and the church with them.

And today, as people from the city begin moving back to the tiny community, taking advantage of the better roads, there is a church ready and waiting for them. The little building has never been more crowded. When the woman was carried to her grave, her coffin was borne by two grandchildren, two great-grandchildren—and two young friends. One of the friends was a photographer, Nick Frey, who took the picture that hangs in the museum. I was one of the grandchildren.

So for me, knowing more of the story, the picture shows a gift being handed from the past to the future. This woman and the other five members did keep the lamps lit and the church open until needed. I think that what you really see in that picture is persistence—and hope.

CHAPTER 22
TRUCK FARMER

His family couldn't believe he was leaving Barnesville, Georgia. "What if you get sick? Who will take care of you?"

But he felt he had to do it, had to move, once he lost the farm during the Depression. He had to find a way to support his wife and five kids on his own, because it wasn't right to make your relatives support you, even if they did say they wanted to help. His oldest son would later talk about that move, striking out into the unknown, going all the way to Green Cove Springs, Florida, as an act of heroism. The family had been in southern Georgia since colonial times.

The son also thought it was remarkable that his father had somehow convinced someone to lend him enough money—money, in the middle of a national financial catastrophe—to get a truck and then convinced farmers to let him take their produce to market on consignment. They called it "truck farming."

The truck farmer drove from town to town—north Florida, south Georgia—with fruit and vegetables packed in shredded newspapers, looking for somebody willing and able to pay enough for him to make a profit. And finding them. Enough people able and willing to pay that he could feed his family. Enough to eventually pay for the truck. Enough over the years to get a house. And, finally, enough to hire a black man to help move the heavy crates.

The truck farmer experimented with different routes, trying to figure out the sequence of towns that would let him sell the most produce while using the least amount of gas. So of course he eventually tried his luck in St.

Augustine. He and his black assistant set up on the side of the road in a likely location.

That's when the police showed up.

Who informed the truck farmer that it was against the law to sell anything without a license. He pointed out that he had been selling produce in lots of different towns and had never heard anything about needing one of those. Well, they couldn't help that. He had broken the law, and he either had to pay a fine or go to jail. Of course he didn't have any money—that's why he was selling produce.

"Well, son," they told him, "we got a solution for you. Just sell enough vegetables to pay your fine."

It seemed to the truck farmer like that put him right back where he started, since he still lacked the license, but he didn't bring that up. He understood by now that this was what they called a shakedown. He also didn't bring up the issue of how they knew he would be back with the money, but he didn't need to bring that one up. The police had already been thinking on that, and they had an idea. They would take a hostage. They would keep the black man in jail while the white truck farmer went and sold his produce. When the truck farmer came back with the money, they would release the black man.

Now, when I heard the story many years later, a number of questions came to mind. First, the truck farmer was the one who had supposedly broken the law; the black man wasn't accused of anything. Why was the black man the

ONE THEORY. *A Florida Cracker in Excitement.* While the whip-wielding Florida cowboy provides the most popular explanation for the term "cracker," the word goes back to Shakespearian times—when it had a meaning similar to "braggart" or "wise-cracker."

one put in jail? Most likely prejudice. But in that case, how could they be sure that the truck farmer would come back for the black man? Once he sold his produce, the truck farmer could have just left town with the money. He'd even have gotten away with not paying the black man, since the fellow would have been in jail. Probably wouldn't have been all that hard to find another black guy to help deliver produce.

The cops were willing to take that chance. And as it turned out, the truck farmer did go back and bail out his assistant, but I don't know how they knew that he would. I suppose there is a lot I don't understand about those days.

The truck farmer sold his produce, took the money to the cops, picked up the black guy and left town. They never did try to sell anything in St. Augustine again.

Did I mention that the truck farmer was my grandfather?

THIS LITTLE LIGHT OF MINE

Mattress Man in the Signal Corps

Now you have to understand, it was pure accident that the signalman saw the beginning of the message. He was just idly scanning the harbor and checking out the other ships in the fleet when he happened to let his binoculars rest on the signal light of one vessel. The light was not turned on, but the guy manning the device apparently didn't realize that. He began closing and opening the shutters to send the dots and dashes of a Morse code communication. The navy relied a lot on ship-to-ship visual systems during World War II, because you couldn't always count on radio contact being secure.

Of course, the light needed to be on for the system to work, because ordinarily no one would realize that you were sending a message until they saw your light, and it would have been impossible to see the shutters opening and closing—unless. Unless the guy on the receiving end just happened to have binoculars trained on your device at precisely the right moment. Even with binoculars it was difficult to read the shutters without a lamp behind them. But our signalman didn't mention that the other guy's light wasn't working, just turned his own light on and confirmed that he himself was ready for the message. And the other guy burned it through as fast as he could, his hand a blur, opening and closing those shutters as fast as possible.

The signal corps was one of those elite units. Not everybody could learn Morse code well enough to use it effectively, and very few could meet corps standards. The navy needed rapid and accurate communications between ships. It could mean life and death in a battle. So the signalmen took a lot of pride in doing their job and doing it well. And to tell the truth, they tended to be a little competitive. They would send code as fast as they

could. If the receiving signalman had to ask you to repeat it, that was great. Meant you won.

Now all this was taking place in the South Pacific, and that was a long way from home for a north Florida boy. He didn't need to go that far to find a war. Heck, ships were being sunk offshore from Ponte Vedra, just south of Jacksonville. But you went where the navy sent you. They probably had a bunch of California boys hunting submarines off the Florida coast.

The South Pacific was a long way from home in a lot of other ways, too. In civilian life, he had worked for his father, even while he was going to school. His father had a big factory that made mattresses. Rebuilt mattresses, too, because in the Depression not everybody could afford a new one. For a lot less money, the factory could take in your old mattress, rip it apart, add a little extra padding and give it back to you almost as good as new. You didn't even have to take your mattress to the factory, because they would send someone to pick it up. Had people going door to door to ask you if you needed your mattress refurbished.

That mattress factory was sure a different world from that of a modern warship. Our signalman read the messages as fast as they came, wrote them down, gave them to an officer and fired back the officer's replies as fast as the original message had come through. Back and forth the communications went, flickering like lightning from one ship to the other.

Back home, most people knew the signalman's father, because the factory was a pretty big deal for Jacksonville. Most people expected the young man to go into his father's business. His future was laid out, and it was a good future. He could look down the road and see how it was all going to unfold, could see the groove he was going to travel for the rest of his life.

But then Pearl Harbor happened, and everything was different. He tried to enlist a couple of times before he could get his father to sign the papers a seventeen-year-old boy had to have, but he finally made it. And out here, in the Pacific, nobody had ever heard of his father or the factory. That was good, as far as he was concerned. He loved his father, and he appreciated the opportunity the factory offered, but the navy was his chance to make it on his own. Out here, all they knew was that he qualified as a signalman. And that he was good.

Still the messages flashed back and forth, faster and faster, each man picking up the other's Morse code, sending back the reply with interest. Each trying to show up the other, but both hanging in there.

The young man would return home after the war, and he would indeed go back to work in that factory. He would branch out later, though, opening

up his own mattress stores in other cities. He would set up other types of businesses. He would develop a "teenage nightclub" to provide a safe place to go for the youth of his community, and he would even get involved in helping to pass legislation. So he had plenty of accomplishments after he left the navy.

And yet.

There wasn't much he did that he took as much pride in as he did his signalman days. And there weren't many times in the signal corps that gave him as much pride as that afternoon.

The two men kept zinging their messages back and forth, each doing his best, neither able to throw the other. A draw.

But then, when the other man signaled that he was signing off, our signalman sent one last message:

"You might want to turn on your light next time."

CHAPTER 24
UNCLE BROTHER

Uncle Brother always claimed that when his parents were growing up, towns were laid out in circles ten miles in diameter with a schoolhouse in the middle. He said that was the only pattern possible, because all of the adults he knew told him they had to walk five miles to school when they were children.

His parents had three girls before he came along, and they all called him "Brother." He was probably lucky he wasn't the first born, because younger sisters would have tagged him with "Bubba." When his siblings grew up and had families of their own, it was natural for their kids to call him "Uncle Brother." Me, I was Uncle Brother's kid.

My father's family lived on a farm in south Georgia until the Depression, when they lost the place and had to move to Green Cove Springs, near St. Augustine. My father achieved a small measure of fame as a teenager by swimming across the St. Johns River, at a point where it's about a mile wide. I was always kind of proud of that. Of course, as a young kid I was proud of a lot of things my father did. And of course as a teenager, I began to notice that he had a few flaws.

The thing is, he was a bigot. Or at least a segregationist. The civil rights movement was really cranking up when I hit my teens, and it seemed pretty clear to me that segregation was wrong. It seemed just as clear to my father that it was the way things had always been and were supposed to be. He'd say things like, "Imagine some poor old guy, worked his whole life, finally got his own store, and now people come and tell him he's got to hire a Negro and work side by side with him."

This was the perfect issue for a teenager to argue with his father about. Because I knew I was right. I might not always have been able to articulate my reasoning the most effective way, but I always knew that reason would support my side. So we argued a lot over the years. And I would argue with other family members and with family friends. Even then, I noticed something. We would get all heated up during the arguments, but when people would interrupt me my father would say, "Now wait a minute, hear him out." Of course he had to say that to me a lot to keep me from interrupting the others—after all, I was right and had stuff that needed to be said—but I thought it was nice that he treated what I had to say as important even when he didn't agree.

I never spent a lot of time back then figuring out why I was an integrationist when almost everyone I knew, grown-ups and teens, were segregationists. When I did think about it, I figured it was my Sunday school and church. Nobody ever actually preached integration, but all that "Do unto others as you would have them do unto you" stuff didn't fit with telling some little black kid he couldn't drink out of the white water fountain. Point is, I was right, and I knew it.

But as I got older, I started to realize some things about my parents. I was never allowed to use the "N" word when I was growing up. If I would even refer to the maid as "that Negro woman," my father would stop me and say, "Don't call her a 'woman,' she's a 'lady.' She works very hard to support her family, even when she has health problems. And she has taken some college courses." I guess you could say I got some mixed messages growing up.

One day when I was almost grown I met one of my father's coworkers, a fellow engineer and a black man. When he got me to one side, the man told me how helpful my father had been back when the coworker first joined the company. As the first black person hired, he had found himself ignored most of the time by the other workers. He said he didn't think they were trying to be rude, they just felt awkward. But anyway, my father would invite him to lunch and went out of his way to show him how things worked in the company. The man said my father's mentoring made things a lot easier for him.

I ran into something similar in later years. My father was a male chauvinist. He strongly disapproved of women's lib, said a woman's place was in the home caring for kids. He believed that a lot of the evils of the modern world—divorce, poorly cared for children and so forth—stemmed from the women's movement. So we argued about that. But it finally dawned on me that my mother had worked outside our home for years. And my father did a lot of housework to make it possible. He washed clothes, ironed,

shopped, the whole nine yards—not just occasionally, but routinely. He never complained, that I heard.

Bit by bit, I realized that if my father was a bigot and a male chauvinist, he wasn't very good at it. It was as though he could swing the theory but not the practice, at least not when it came to actual people. Now I was PC before PC was cool. I had, if I do say so, a fine instinct for adopting the "good" political positions. My father was never PC in his life. But the truth is, he walked the walk that I mainly talked.

Well anyway, as my father and his sisters got older and had grandchildren, family relationships got more and more complex. There were nieces and nephews and first cousins, also second cousins and first cousins once removed and children of the second wife's first marriage. The family stayed close over the years as it grew, and there were lots of get-togethers. My father was pretty much always there, so everybody knew him well. But I moved out of state and wasn't able to get to these gatherings as often as I would have liked. So sometimes, as I would be talking to some kinsman or other at a reunion, I could tell the person wasn't quite sure who I was or how I fit into the family.

And I would always point with pride to my dad and say: "That's my father, Uncle Brother."

CHAPTER 25
WAITING FOR JINGLE BELLS

Santa took him a swig, sitting among the tombstones on Christmas Eve. It was the custom, after all. His peculiar-looking mask hung around his neck now, the wisps of cotton beard and hair sticking out at odd angles, the once-ruddy face gone bright orange over the years. He gulped fresh air, exhaled little clouds into the frigid air. His face was too hot with the mask on, too cold with it off. The red stocking cap, functional tonight, was pulled over his ears. The red suit was pulled over a couple of flannel shirts and a pair of dungarees, the shiny black leggings wrapped around his cowboy boots. Santa stomped the ground a little, trying to get the feeling back in his toes.

Some years Santa sweltered in the heat, the raggedy wool suit itching, sweat dripping. There was a hard freeze tonight though, bad for the orange groves but good for that Christmas feeling, thanks to Yankee propaganda. If you had to have one or the other, frost was probably better than heat for a Santa stuck in the churchyard waiting for his cue. It was easier to layer up against the cold than to cool down a wool suit. And cold gave you an excuse to take a nip or two; people kinda expected it.

Strands of a hymn came through the little church's windows: "Oh come, oh come, Emanuel." So the service had started at last, but there was still plenty of time before his appearance. He shuffled around the cemetery a little, beat his arms, trying to get his blood moving. He could have waited in his truck, kept the heater going, instead of out here in the cold. But what if some kids had shown up once he was kicked back, seen Santa with his mask

New Hope Church. Scene of "The Picture" and "Waiting for Jingle Bells." *Author's collection.*

off? No, he waited out of sight like all the Santas before him. Putting up with the cold was just part of it, part of the rent you paid for the good stuff.

He moved among the tombstones. There was no path, but he was able to see well enough in the dark to keep off folks' graves. At least the ones he knew about, the ones who still had stones or markers. Those cast-iron markers, the Maltese crosses, they belonged to the Confederate veterans. One grave held a man who was a Seminole War veteran. The really old graves had stones with the letters worn away, and they were lined with seashells, tokens of the pilgrim way. The small stones, with lambs or weeping cherubs, they were for children, babies. There were a lot of those in the old section.

He supposed you could argue that spending an evening in a cemetery was more suitable for Halloween than for Christmas. But this wasn't that kind of cemetery. He was among friends here, maybe more so than when they were above ground. This cemetery always felt like Christmas, even before the Santa gig, because it was one of the times of year he made it a point to visit Sarah. They had spent forty-seven years bickering with each other. For five years now he hadn't had anyone to set him straight. He glanced at her stone but didn't stop, because he had been here earlier today putting a Christmas

bouquet on top of her grave. He'd have to come back in a day or two to retrieve it; didn't look good to have dead plants all over the place.

He stamped his way back over toward the little church, hugging himself for warmth. He looked in a window, saw the familiar dark paneled wood walls with white trim, the ornate potbellied stove, the crude wooden pews. There was a Christmas tree in the far corner, cedar branches creating halos around the old-fashioned lights. A teenager was reading the Bible at the lectern that served as a pulpit. He couldn't make out the words, but he could see some children dressed up as Mary and Joseph kneeling beside a doll in an orange crate manger. So they had gotten the Holy Family to Bethlehem already, but no shepherds or angels yet. He still had a good wait. He didn't recognize the teenager or the children by the manger, which meant that they were ringers imported from a slightly bigger church in the nearest town.

"Away in a Manger" made its way through the glass. He had a few mangers scattered around his place, 'cept he called them feed troughs, but mostly he just chunked a few bales on the ground for the livestock. "The cattle are lowing…" Yeah, probably so, up among the scrub oak in the northwest corner, huddling together, trying to get the frost off their backs. He'd have to put up a barn for them one of these days.

He ducked under some branches, brushed aside the Spanish moss, as he moved toward John's grave. Gone a long time now, still probably the best friend he'd ever had. John would drive up on a Saturday, Sarah scowling at the dust cloud long before the old Ford could be identified, knowing who was coming, knowing where they were going. "Mr. Potterson," John would say after he had greeted everybody, "I was just heading into town, wondered if you needed to run in for anything."

"Why yes, Mr. Samuel," he would reply, "I believe I do need to pick up a few things, and I would appreciate a ride."

They would head off together, buy a few supplies, visit with the boys on the bench in front of the feed store. Then driving back, passing the Wishing Tree Bar, Mr. Samuel would always say, as though struck with a sudden thought, "Mr. P., would you be thirsty by any chance?"

"Thirsty? Well, you know, now that you mention it, I believe I am a little on the dry side."

"Do you suppose they would have something in the Wishing Tree that might fix us up?"

"I wouldn't be surprised if they did. I guess we could check and see."

And the next Saturday, they'd do it all again.

The Wishing Tree was still there, and Sarah wasn't around to object, but it wasn't the same anymore. He tipped a little of his flask out onto old John's grave, wished him a Merry Christmas. Took another pull himself by way of a toast. He read John's stone again, just a name and a couple of dates, the first one eighteen something or other. He'd never had any idea John was that old until he'd seen that marker.

Back to the window to check, keeping in the shadows; couldn't let himself be seen too early. "Hark! the Herald Angels Sing," little girls with tinfoil wings standing behind the Holy Family now. He rubbed his cheeks, blew into his gloved hands, trying to deflect warm breath back on his face. Man, that temperature was still dropping. He pulled the starched cloth mask back over his face to keep the night air off for a bit. Couldn't leave it on too long, though. Wouldn't do to start sweating again. He arranged the wisps of beard, wandered off away from the window.

He could barely hear it, coming from the church. "There's a star in the sky, there's a song in the air…" He looked up through the branches, into the still cold night. There certainly was a star in the sky, maybe a million of them, brilliant, maybe one of them the star, the star that had guided the wise men. Maybe that big one over there, in that patch of sky between the trees. "The star rains its fire while the beautiful sing…" He moved back toward the little building, peeked in the windows again. Shepherds standing behind the Family, angels behind the shepherds, the tableau moving toward completion.

It'd be nice to be inside, listening to that story again. But he knew it pretty well, and that building was probably overheated, stuffy. He'd be inside soon enough, and long enough. There was a time when he had appreciated an excuse to be outside the church looking in. He and John, they were always there on workdays, fixing up the roof, putting up a new outhouse, hauling off a fallen tree, while the women hoed the weeds out of the cemetery, scrubbed off the tombstones, planted a few periwinkles or marigolds around the church. Come Sunday, though, the women had the building to themselves more times than not, except for Easter and Christmas.

"I do believe you have a secular sensibility, Mr. P.," John had teased him.

"Why, I believe you may have one of those yourself, Mr. S.," he had replied. Well, these days he tried to be inside on Sundays. But it was nice to be out here tonight, listening to the music, watching the story, sensing it come alive again.

The wise men, bathrobes a little too long, golden pasteboard crowns sitting at all angles on their heads, shifted from foot to foot in the back of the church, wise enough to wait for their proper moment. "We Three Kings…" King and God and Sacrifice.

Time to check Santa's sack. He pulled out a little cellophane bag. It had an apple, two candy canes, three pieces of hard candy and a chocolate-covered cherry. The apple would probably be sticky by the time it got home. He was supposed to give every kid in the place a bag, the grown-ups too if they wanted one. He put it back, pulled out a small wrapped package, shook it. It would have either a pen or a handkerchief inside. Every child would get one of these, too, but there wouldn't be enough for the grown-ups.

Most of the kids were probably a bit puzzled by the little gifts these days. They got all kinds of gizmos and fancy stuff, couldn't get excited about a handkerchief. But there were still a few children, thin and clinging to parents with deep-lined faces, this was all the Christmas they were going to get. And so one Santa or another had been hanging out in the cemetery since the Santa suit was new, since the mask was jolly with rosy cheeks and fluffy beard.

"Silent Night." Almost time. He hoisted the sack on his back. He walked toward the gate, eased it open, tried to keep it from clanging when it swung shut. The congregation switched to "Jingle Bells." Showtime.

"Ho! Ho! Ho!"

An old man in a ragged suit and a frightening orange countenance and whiskey breath walked out of a graveyard and up the steps to the little church. And Santa Claus came in the door.

CHAPTER 26

THE FEROCIOUS FLEAS OF MARJORIE KINNAN RAWLINGS

Pest control work is not as glamorous as it sounds. It is true that you have that whole "ghostbusters" image going for you, with the coveralls and the tanks with nozzles that you carry around, and goggles if you want them. But the glitter loses its appeal as you deal with the day-to-day reality of the job. And the reports of pest control groupies turn out to be a cruel hoax. The truth is, the places you get sent to tend to be roach infested, and sometimes there is an obvious reason for the problem. You get to see some really nasty living conditions in that profession.

I worked for the pest control division of the University of Florida, just before the environmental movement caught on and made a lot of our techniques illegal. Most of what we did was to go around the various buildings the university owned, spraying for roaches or termites. Sometimes we would "tent" houses, which meant that we constructed a covering for some old house by pinning tarpaulins all around it and then pumped it full of poisonous gas. That's what you did if a place was too infested for ordinary spraying to handle.

When you tented a house, someone had to stay all night to make sure no kids or animals sneaked inside. And as the new guy, that "someone" was generally me. On the other hand, I occasionally got assigned to the coveted "rat patrol," a job that let you tool around by yourself in a jeep, setting up poison bait stations on the university's farms. Gave you a little independence and responsibility.

I worked in pest control as a way of paying my way through the university, but I believe I may have learned as much on the job as I did in class. I

certainly met people who were different from anyone I had known before. The supervisor himself—I don't remember his name—came from UpNorth. He was a pro-union man, the first I had ever met. In the part of the South I grew up in, that was a lot like being a communist.

Now Ajax…I suppose you could have said that Ajax was a redneck, and I don't believe that would have offended him. He liked fishing and hunting, of course, but his favorite sport was fighting. I'm not talking about boxing, or professional wrestling, or any other kind of spectator sport. He was more of a hands-on kind of guy, and he would seek out those bars like the Purple Lizard or the Bucket of Blood, where fighting was the main attraction. He'd come in on Mondays all banged up, with a big grin on his face. Met his wife when she protected his back during one of his set-tos.

Joe and Sly were a few social rungs below Ajax; they would probably never achieve the lofty status of redneck. Nor, I think, did they even aspire to the more attainable goal of white trash. Like Ajax, they would hang out at bars and quarrel with the other patrons. But unlike Ajax, they wouldn't get into fights. What they would do was wait until later, when the guy they had disagreed with was walking home. Then they would glide up behind him in their pickup and whack him on the back of the head with a full bottle of beer. Wouldn't wait around to see if they'd killed him. They bragged about such accomplishments, having astonished themselves with their own strategic vision. The two of them lived in a town near a major prison, and I figured that was a good thing. Would save on transportation costs some day.

Ajax was a great worker, whether anyone was around or not. He had an ability to see what needed to be done, and he liked to stay busy. Joe and Sly were terrible workers, always slacking off if nobody was watching. They would spend a morning loading boxes onto shelves and then unloading them, over and over. The idea was that they were less likely to be given an assignment if they looked busy. Of course, there were few assignments that worked you as hard as their shelf-stocking scam, but avoiding the tasks they were paid for seemed to be a matter of principle to them.

One time the supervisor had Joe and me painting some old building. Joe was creeping along, dripping paint everywhere, leaving a bunch of unpainted places. All of a sudden he called me over.

"I know what you're thinking," he said. "But let me show you something."

He proceeded to paint circles around me, beautiful work, not a drop spilled, not a brushstroke showing.

"Now that's the kind of job I would be doing if I was being paid painter's wages. But since I'm being paid minimal wage, I'll work the way I always do."

I did wonder why he didn't show people he was worth more than minimum wage, so that he would get offered a better job, but I didn't say anything. I didn't want a truck gliding up behind me some dark night.

Anyway, one day the supervisor came to us with a grim look on his face. He said we had to go out to some old house the university owned, way out in the country. He mentioned that it used to belong to a writer named Rawlings. And I knew that writer!

It had to be Marjorie Kinnan Rawlings, the author of *South Moon Under*, *The Yearling*—and *Cross Creek*. I had read her books. As an only child, without a working TV in the house, I had read a lot of authors. But even my high school friends, who were not a particularly literary bunch, had read Marjorie Rawlings. She lived in St. Augustine for many years, but she became famous for what she wrote when she lived in Cross Creek, which was near Gainesville. And she wrote about the area. While most books were set in Europe or Mars or New York or some other mythical place, Rawlings wrote about places we knew. Made them seem important somehow.

And that home we were going to…that had to be her famous house at Cross Creek. I had been trying to see that place for years. And I probably had seen it, at least from a distance, because I went fishing at Cross Creek a lot and the house was supposed to be on the main road. But I didn't know which structure it was, and I figured that I wouldn't have been allowed to go into the yard to really look around even if I had known where it was. I vaguely remembered hearing that the house had been given to the University of Florida.

And now, because I worked for the university, I was going to get my chance to see the place. Ajax and Joe and Sly and I. Not under the auspices of the English Department. Under the auspices of the pest control division.

Anyway, the supervisor made it clear that this was no routine job. This was going to take all of us. And it was going to take some special precautions. He loaded us up into two trucks. He and Ajax went in one—he wouldn't ride with Joe and Sly if he could help it—and the rest of us in the other. Lots of canisters of different sorts sat in the back of the trucks.

We rode out to Cross Creek, a beautiful trip. It was always fun to get out of Gainesville, but I was really looking forward to finally seeing the Rawlings place. Of course, I knew I wasn't going to see Rawlings herself, since she had been gone for years, and I understood that we were not going to a museum. At that time the university was treating the place like ordinary rental property. Some family was occupying the house; apparently a family with a major league pest control problem.

Still, when we pulled into the driveway, I was a little disappointed at how run-down the place was, with weeds everywhere. Dogs lay all over the porch, and they were indirectly the reason we were there. Because we had been called to exterminate fleas.

Well, I knew a lot about fleas, even before I worked for pest control. If you have pets, they'll probably get fleas sooner or later. You can have the pets dipped or get flea collars for them, but it's usually no big deal. Worst-case scenario, you throw a bunch of powder onto the yard. I couldn't figure out why the supervisor was looking so grim. Couldn't figure out why we parked so far away.

We got out of the trucks, unloaded our supplies. We pumped up the pressure in our tanks, made sure our nozzles weren't stopped up. We were on.

"You'll need to tuck your trouser legs into your boots or socks," the supervisor said. "You might want to lightly spray your pants before we get started."

He walked out into the yard. And his legs, up to the knees, seemed to vanish in a cloud of some kind. I looked closer. Fleas were boiling up with every step. I was astonished, never had seen anything like it. I couldn't understand how there could be people left alive in that house, never mind dogs. It seemed to me that there were enough fleas to skeletonize a herd of cows. I had often been disgusted on the pest control job. This was the first time I had ever been afraid.

We all tucked in our pants legs a little tighter. I sprayed some more pesticide on my pants and socks. Then we formed a picket line and moved out across the yard. We walked slowly, swinging our nozzles in a semicircular pattern in front of us as we walked, trying to overlap with the guys on either side. When we reached the far side of the yard, we wheeled around and then moved across the yard again, a few yards over. Again and again. When we finished the whole yard the first time, we went over it once more at right angles, trying to make sure we saturated everything. I don't remember what we were spraying, but for years after I left pest control work the government sent me questionnaires asking me how many thumbs I had.

We didn't go inside the house, and I don't remember going into the orange grove that stands beside it today. Actually, I don't remember an orange grove at all; I imagine it was pretty well overgrown in those days.

When we finished spraying, we stood brushing at our pants for a long time, trying to be sure we didn't take any fleas back with us. I guess the treatment worked, because we never got called back to the house while I was with the pest control division.

Well, no one has any trouble finding the Rawlings house at Cross Creek these days. The place has been turned into a state park and is well marked.

THE FLEAS ARE GONE. While Marjorie Kinnan Rawlings lived in St. Augustine, her years in this house at Cross Creek made her famous. Marjorie Kinnan Rawlings Historic State Park. *Author's collection.*

There is a festival there every year. I have visited the park several times, because it is a beautiful location now. The main house gleams with fresh paint, the orange grove and outbuildings are nicely maintained. The whole complex probably looks a lot better than it did when Rawlings lived there. When I try to picture how she lived, I try to imagine something between the way the place looks today and the way it looked the first time I was there.

I still read her books and short stories from time to time. I don't really blame her for the fleas.

CHAPTER 27

JAMESTOWN AND THE ANCIENT CITY

In 1965, I took my girl to a play called *The Cross and the Sword*, part of St. Augustine's 400th anniversary celebrations. It must have worked, because she married me shortly after that. A number of years later, we followed with interest another 400th anniversary celebration, that of the founding of Jamestown, Virginia. They got the queen of England to come, and the shindig got a lot of ink. Good for them. The town was founded in 1607, twenty years before those Johnny-come-lately Pilgrims moved into New England, which makes it the oldest enduring English settlement. As it happens, St. Augustine, "the oldest European settlement," and Jamestown, "the oldest English settlement," have a number of historical connections. And the most important was this: the fate of each city depended on the other. It all came down to two ships.

The link between Virginia and Florida started early. In fact, according to the Spanish, Virginia was part of Florida, as was the rest of the Southeast. Right after he destroyed the French army at Matanzas, Pedro Menendez urged the Spanish king to build a fort at thirty-seven degrees north, which is in the region that would be called "Virginia" in a few decades. And that is the region where the English would someday place a settlement called Jamestown. The king of Spain tabled the motion for the nonce—a really long nonce. Which, in retrospect, might have been a mistake.

Menendez's request shows that the Spanish were thinking about the future site of Jamestown long before the English got there. And the English did a lot of thinking about St. Augustine. When the Jamestown investors were trying to decide whether to finance a Virginia colony, the Florida city was very

much on their minds. And so was Pedro, although of course he was long gone by then. Because that story about him destroying the French army served as a dreadful warning to anybody contemplating a New World venture. The Spanish were formidable and prepared to be ruthless if necessary. So an important question for the Jamestown company was whether an English colony would be strong enough to defend itself against St. Augustine. Could a Virginia settlement avoid the fate of the French at Fort Caroline?

In 1606, word reached the Spanish court that an English settlement in North America was being planned, and the government shifted into its lightning-fast action mode. By March 1607, the Council of War in the Indies recommended that "all necessary force should be employed to hinder this project." But nothing except talk happened for a while, and the talk did not remedy the situation. Finally, in 1608, the King's Council of State concluded that "this matter of Virginia is not to be remedied by any negotiation but by force." So the Spanish king ordered St. Augustine's governor, Pedro de Ybarra—the one who had been captured by pirates on his way to work—to send a ship up the Florida coast to investigate what the English were up to. The Florida coast that included Virginia.

In July 1609, a mere forty-four years after Menendez's recommendation, and a time-blink of three years after the court got word that the English were making their move, a vessel under the command of Captain Francisco Fernandez de Ecija sailed into Chesapeake Bay. Its assignment was to deep-six Jamestown. That was the first ship of this story.

But before he could find the forbidden English settlement and destroy it, Fernandez encountered the second ship of the story—a large ship, commanded by Captain Samuel Argall (the guy who captured Pocahontas). Since Argall's ship was bigger, Fernandez decided that heading back to St. Augustine was the prudent thing to do. The Spanish captain urged the king to send more ships to destroy the little town. But in the end, despite the urging of his councils, the king dithered. Jamestown was spared.

If the St. Augustine ship had arrived a week or two earlier, or if the English ship had been smaller than the Spanish, or if Pedro Menendez had been in command of the Spanish operation, Jamestown probably would have been snuffed out in its cradle. It is interesting to speculate on how the history of North America—heck, the history of the world, since there might never have been an American Revolution—would have been different if England had not gained a foothold in the New World.

Now you can argue that the settlement of Jamestown was a disaster for St. Augustine. Before Jamestown, the English sent pirates like Sir Francis Drake

to sack St. Augustine. Within a hundred years of Jamestown, the English were sending armies to occupy it. Because Jamestown endured, other English settlements were founded, and these colonies were enemies of anything Spanish. Carolina launched an invasion against St. Augustine during Queen Anne's War, and Georgia's Governor Oglethorpe led a force south during the War of Jenkins' Ear. Both ventures failed to take St. Augustine because that massive fort was in place. But the invasions devastated Spain's extensive chain of missions, plantations and lesser settlements. To a great extent, Spanish Florida was pushed back to St. Augustine's city limits. Arguably, it happened because Menendez's advice wasn't taken, and Spain failed to prevent the founding of Jamestown.

But there's more to the story. If the establishment of Jamestown eventually led to the destruction of most of Spanish Florida, it may have saved St. Augustine itself. Before Jamestown, the colonial authorities in Havana had been trying to shut down St. Augustine; the bean counters argued that it made no military or economic sense to maintain the Florida outpost. But once plans to build Jamestown came to the attention of the court, St. Augustine suddenly appeared indispensible. Maybe the Spanish didn't particularly want Florida for themselves, but they sure as heck didn't want the English to have it. Not only was the city not abandoned, but the government even sprung for a new stone fort, the Castillo de San Marcos.

Jamestown was founded in 1607, St. Augustine in 1565. Those old dates tend to run together in our minds. But between those two dates, the scientific revolution flourished, the balance of power between empires shifted and the world changed. And fifteen years after St. Augustine was founded, Captain John Smith—who would someday be a founder of Jamestown—was born.

Forty-two years from the founding of St. Augustine to the founding of Jamestown. Foreshortened by the centuries, that span of time looks like nothing, a mere technicality in the "oldest city" contest. What does forty-two years really mean?

Well, since I courted my girlfriend way back in 1965, at St. Augustine's 400th celebration, we got married and had two children—both now grown and living on their own. I graduated from college, went to graduate school, completed an internship and a post-doc, worked at several jobs, stayed with one long enough to retire. Forty-two years. Much of an adult lifetime today, greater than total life expectancy in the 1500s. That's how much older St. Augustine is than Jamestown.

If you happen to be anywhere around St. Augustine near 2015, help us celebrate our 450th anniversary. I've had pretty good luck at these things.

WHEN CRACKERS MET SPANIARDS

Bloody Marsh Reenactment

Farb" is the thong underwear beneath the hoop skirt. It's the plastic button on the Revolutionary War uniform, or the New World vegetable at the medieval feast. "Farb" is a term that some reenactors use to indicate something that is inauthentic, not appropriate to the period they are trying to depict. And authenticity is highly valued by reenactors. For some, the experience serves as a kind of time travel, something that helps them get a feel for what it must have been like to have really been there.

I have always thought that I wanted to get into reenacting, especially once I got to St. Augustine, but so far I have been held back by my twin afflictions—I'm awfully lazy, and I'm cheap. It takes a lot of work and some expensive gear to do reenacting the right way.

Reenactors don't really do their thing for public acclaim—I suspect they enjoy the experience more after the public leaves. But the public benefits. Especially those of us who have limited imaginations, who go to a Civil War battlefield and can't quite shake the feeling that Lee should have attacked down the ninth fairway, or that Sherman would have done better to take shelter behind the cloverleaf. It really helps people like me to see folks in authentic costume and to visit their campsites.

My wife and I were in Darien, Georgia, at Fort King George, for a reenactment of the 1742 Battle of Bloody Marsh. OK, it's not Gettysburg or Chancellorsville. It's not even Civil War. Or Revolutionary War for that matter. The War of Jenkins' Ear is just not one of your biggies, as far as the

history books go. Never caught on for some reason. But then again, this particular battle commemorates one of the few times that Florida invaded Georgia. I think it's fair to say that this was probably the largest Spaniard-cracker showdown north of the Florida line. Did I mention that it was free?

I'm a history buff, and my wife Sharon puts up with it, so we had been to a lot of Civil War (War of Northern Aggression) reenactments, even more medieval reenactments (don't ask) and a couple of pirate raid reenactments, but this was our first colonial battle. As I think about it, maybe we need to hit the nightclub scene more often. But anyway, this was our first colonial battle, and this reenactment felt different. I had some strange feelings as I watched the Spanish army close in on the British ambush. I wasn't sure whom to root for.

On the one hand, the Spanish army came from St. Augustine—both the originals and the reenactors. And I live in St. Augustine, so the Spanish were the home team. In any of the reenactments we had watched in St. Augustine, pitting pirates against the Spanish, it was natural to root for the Spanish.

But here in south Georgia, with the Spanish fighting the British, it suddenly felt more complicated. To start with, the movies and TV shows I was raised with had simple rules: if Americans fought the British, then the Americans were the good guys and the British were effete fops. But if the British fought anybody else, then the British were hearty, freedom-loving yeomen and their enemies were cruel despots. On the other hand, with the exception of Zorro, Spanish warriors were fat, bombastic and cowardly.

There was more. I realized that I just might have "people" among these British troops. Because the soldiers in red coats depicted by the reenactors were not supposed to be troops from overseas, they were supposed to be settlers from the region. And my family, like a lot of Florida families, came from south Georgia originally. In fact, the odds are pretty good that I am descended from some of those very highlanders from the village of Darien who were represented here. For all I know, I might be related to some of the reenactors, since most were probably local. If the battle hadn't gone the way it did, a defeat for the Spanish, there is a fair chance that I wouldn't be living in Florida at all, much less in St. Augustine.

And there was something else making it hard to root for the home team. I had been raised with "The Black Legend." Them Spanish were supposed to be mean dudes. All of my textbooks had talked about the cruel, tyrannical dons and their fondness for inquisitions. This was contrasted with the brave, freedom-loving English.

But since I had been living in St. Augustine, I had been exposed to the other side of the story. The British were trying to take land the Spanish had stolen fair and square from the Native Americans. Also, the real-life Sergeant

Garcias weren't the pushovers they were on old TV shows—they had fought well against fearful odds. Finally, I knew that Native Americans tended to be treated better by the Spanish than by the English and that blacks had a better chance for freedom in Florida than in Georgia during colonial times. From an ethical standpoint, I should be rooting for the Spanish.

Then it occurred to me: we knew who was going to win this battle. I was spending an awful lot of time deciding whom to root for in a fixed game. Maybe it was a guy thing.

Of course, the battle itself is usually the least authentic part of any reenactment. Face it, people hide when someone's actually shooting at them, so the real battles were usually in woods while the reenactments are in fields where spectators can watch. Besides, park archaeologists never let you use the actual site because they don't want phony artifacts all over the place. But anyway, the Spanish walked into the British ambush and were chased back, and we got to see people firing all those black powder weapons.

After the battle was over, my wife and I walked over to the merchant/craftsman area to watch blacksmiths and weavers and such do their thing. My wife, more gregarious than I, made friends with a local woman who offered us a paying storytelling gig. Using that family instinct for high finance that has been the foundation of our fortune, my wife explained that getting paid was not for the likes of us, that we were too new to expect any kind of compensation.

There were period encampments set up to demonstrate life for the Highlanders, Spaniards and Native Americans. That got me to thinking about the lives of the people who fought here and the lives of the communities they were defending. The reason the Highlanders were in Georgia learning to like grits and hush puppies was that they had been kicked out of Scotland so the landlords could raise sheep. Then they'd been almost wiped out a couple of years earlier, in the Battle of Fort Mose, outside of St. Augustine, when Georgia invaded Florida. And when they became civilians after the war, their labor was worth less because the local landlords brought in slave labor.

The Spanish had their own hardships. The reason they were in Florida learning to cook with datil peppers was that they had been drafted. Looking over the records, one fact kept coming up—most residents of St. Augustine, during most periods of history, wanted to be somewhere else. They went through the "Great Indian Rebellion," the "Great Hunger," the "Great Storm," the "Great Freeze" and various calamities that I suppose were merely "OK" catastrophes. They endured plagues, pirate raids, years of no supplies and no money and battles with the Spanish crown, as well as battles with people from UpNorth. Time and time again the governors complained

NOW IMAGINE THE MOAT FILLED WITH COWS. View of the Castillo de San Marcos. The fort is not just a stone box but rather an intricate system of defense, each part of the wall subject to fire from another part. *Author's collection.*

that the soldiers and civilians wanted to leave. Being sent to St. Augustine was often a punishment for less-than-diligent troops.

As I thought about all of this, a new and loftier rationale for not participating in reenactments began to occur to me. This business of deliberately trying to put yourself in those bleak conditions of old St. Augustine, when the actual residents had tried so hard to escape them…wasn't that kind of farb?

Later, as I was watching a company of Spanish reenactors drill, a Highlander in full regalia began taunting them about losing the battle. The Spanish sergeant came charging over. I thought he would respond in a historical context, counter-taunting about the British defeats at St. Augustine. But he took a more present-centered approach. He pointed to the blockhouse of reconstructed Fort King George and asked: "Who was sleeping in that snug blockhouse this morning? Who's going to be sleeping there tonight? And who's going to be sleeping out in the open, with all the palmetto bugs? Tell me again who won?"

It looked like they were having fun. It was a shame my afflictions held me back from participating.

It Was Along 'Bout Then

Historical Background of Stories

Do you remember Obama's election? How about the controversial George Bush/Al Gore contest in the year 2000? Think of all that has happened since then. Go back, if you're able, to the first George Bush and the first Gulf War. Now let your mind range even deeper into the past. Remember, or recall what you've seen in history books, of the Vietnam War, the McCarthy hearings, President Eisenhower, World War II. See time unspooling, as we move through the Depression to World War I, to the Spanish-American War. Move far beyond living memory to Custer's Last Stand, to the Civil War. Back, still back, to the coming of the telegraph and the steam engine, to the War of 1812 and finally all the way to 1776 and the birth of the United States. It seems an incomprehensively long period of time.

But we're just getting started. We have to go back almost that far again before we get to St. Augustine's founding, even further before we get to the first European contact with Florida. As we've mentioned, 450 years is a lot of history, and a lot of time to grow stories. Here is where the stories in the book fit into this history.

1) "Hernando de Soto and the Mime of Doom" (1539)— After Cortes struck it rich by conquering the Aztecs in 1519, other Spaniards wanted a piece of the action. De Soto, a veteran who had soldiered with Cortes and Pizarro, hit the Florida beaches around Sarasota in 1539 and marched north. On his journey across *La Florida*, aka the Southeast, he lost over half of his men, all of his horses and himself. It turned out that native arrows could penetrate European armor and native bows could reload faster than muskets. Judging by the historical markers, he passed by every small town south of Ohio.

Our story takes place just before that grim trek, when de Soto stopped off in Cuba on his way from Spain to disaster. St. Augustine's founding was almost thirty years in the future, although Florida was already racking up some history. The events described in our story actually took place (incidentally, they later found the owner of that dog rescued in the middle of the Atlantic). De Soto was searching for gold, and there really was gold in Florida. But it had washed up from Spanish shipwrecks.

2) "Four, Three, Two, One: Don't Mess With Pedro" (1540s)—Pedro Menendez, the founder of St. Augustine, had a reputation as a great seaman and one heckuva fighter. The battle against pirates described in our story did take place, twenty years or so before St. Augustine was founded, and it jump-started his career. He was eventually made captain general of the Spanish treasure fleet and was the original admiral of the Spanish Armada. His interest in the Sunshine State resulted from the loss of his son during a storm off the coast of Florida—as a condition of being allowed to search for his son, he had to agree to explore and colonize the peninsula.

Unfortunately for Spain, he died before the Armada sailed for England. This book might have been written in Spanish if Pedro had been around to lead that invasion.

3) "If You Can Keep Your Head, When All About You Are Losing Theirs…" (1565)—Because this story tells about the founding of St. Augustine from the French point of view, it downplays Menendez's valor. When the hurricane scattered Ribault's fleet, Menendez didn't hesitate but promptly led his men through the storm to attack Fort Caroline. The Spanish slogged through swamps, hacked their way through thick woods and crossed neck-deep swollen streams to attack an enemy armed with cannon and protected by walls. After taking the fort, Menendez got word that the French fleet had been shipwrecked and enemy troops were heading for St. Augustine. He took fifty men and marched to meet two hundred of the enemy at an inlet that was to be called Matanzas—"slaughters."

The massacre of the French shipwreck survivors was widely condemned by Protestants, of course, both at the time and later. Writing in 1858, American historian George Fairbanks described the act as "a monstrous atrocity, when committed against people of a sister nation." Some of Menendez's own men condemned his cruelty when they heard what he had done.

But others said that he could not have acted differently even had his prisoners been Catholic; provisions were inadequate for so many people, and

the French, once they realized their numerical advantage, would surely have overcome their captors. There is also this. By the time the final 150 shipwrecked survivors surrendered some days later, Menendez was feeling more secure. On that occasion, although his new prisoners were just as Protestant as his previous ones, he did not execute them but sent them back to France. From our safe vantage point, we can certainly say that it would have been a fine and noble thing had Menendez risked the lives of his own men in order to spare those of the enemy. But it is perhaps understandable that he did not.

Nicholas Borgoignon, our French fifer, played the "March of the Prince of Orange"—then considered to be the most anti-Spanish piece of music in the world—as a don't-shoot-me signal when he met Drake and his pirates. However, there is disagreement among my sources as to whether he had been captured during the events at Matanzas or some years later. I have not attempted to resolve this dispute because of my affliction (I'm awfully lazy).

4) "Payback" (1568)—Dominique de Gourgues, the avenger of the Matanzas massacre, was a French soldier of "ancient family and high renown." After his time as a Spanish galley slave, he made his reputation as a nautical warrior and was given many prestigious commands. His biographical sketches comment on his extensive experience sailing to Africa and Brazil, so I suspect that the voyage in our story was not his first experience with slavery.

France was in turmoil at the time of the Matanzas massacre, facing possible civil war. The conflict was partially between Protestants and Catholics, but it was also a conflict among various political factions—each of which sometimes allied with Protestants and sometimes with Catholics. A few short years after the events of this story, there was a horrific massacre of Protestants in France itself—the St. Bartholomew's Day massacre, in which between five thousand and thirty thousand people were killed. It is easy to see why the French king would have been reluctant to highlight the Matanzas massacre in the volatile climate of the time.

De Gourgues was *persona non grata* with the French king after exacting his revenge on Fort San Mateo and was exiled from court for many years. However, many French nobles befriended him while he was out of favor, and the king eventually relented. Queen Elizabeth I invited de Gourgues to join her service as an admiral, but he died while on his way to Portugal to fight the Spanish yet again.

5) "A Funny Thing Happened on the Way to the Office: Governor Ybarra Loses His Shirt" (1603)—Getting to St. Augustine was a dangerous

proposition in the seventeenth century, even for a governor. A not-so-cold war raged between Spain, which posted "keep-out" signs on the New World, and the rest of Europe. A war waged through pirates. The warring nations issued letters of marque, government permits to rob and pillage the enemy's commerce; most pirates claimed to hold one of these letters. The letters could be forged, but legit ones were pretty easy to come by—at least one governor of Jamaica issued them long after the king told him to stop. Those who held such letters didn't necessarily follow a strict interpretation of the stated conditions—the buccaneer Henry Morgan attacked the city of Panama although his letter gave no such authorization, and a bunch of other "privateers"—letter holders—attacked ships of friendly nations. When peace sporadically broke out, and the pirates/privateers were called in to surrender their letters, many refused. Actually, periods of peace tended to inflate the supply of pirates as unemployed soldiers and sailors looked for alternate career paths. Large-scale piracy stopped only when the major nations decided it was disrupting trade too much.

Unfortunately for Governor Ybarra, he set sail for Florida around the time of Queen Elizabeth's death in 1603. Peace among the nations of Spain, France and England had just broken out, and pirates were a glut on the market. Ybarra's adventures unfolded as described in this story, and he really did have to borrow a frigate and a clean shirt from the governor of Cuba.

6) "The Pirates of Paynes Prairie and the Accountants of the Caribbean" (mid-1600s)—Spain regarded St. Augustine as a military base rather than as a commercial enterprise and made few serious efforts to develop it economically (hey, we don't insist that Fort Bragg, or Fort McClelland, turn a profit). This may be one reason why the English colonies flourished while La Florida tended to stagnate.

Don Thomas Menendez Marques was an exception to the usual Spanish disinterest in commerce. As the story says, his cattle ranch, "La Chua," flourished; it gave its name to Alachua County and the town of Alachua. Some of the cattle escaped and became the wild cows that later Florida cowboys hunted down to start the modern ranching business in the state. Descendants of Don Thomas's cattle fed the Confederate army, and Florida today is second only to Texas as a producer of beef. Those pirates may have been on the right track when they decided to go after meat instead of gold and jewels.

Accountants did routinely short-change St. Augustine, although for the sake of the crown rather than personal profit, and the garrison soldiers did basically pay for the Castillo de San Marcos with their wages that were withheld.

7) "Was Sotolongo Really So Wrongo?" (1668)—Sotolongo may sound suspiciously modern in his plea for tolerance and the essential equality of different races. After all, we all "know" that the Spanish, and especially their religious types, were cruel, intolerant and fanatical. But that is a view promoted by an anti-Spanish propaganda campaign called "The Black Legend." Actually, if you were African, Native American or an accused witch, you were better off with the dons than with the lobster-backs. A lot of what we "know" just ain't so.

Much of the Black Legend was promoted by Protestant politicians who liked to attribute Spanish cruelty to their Catholicism. But this gets it backward. The popes and high church honchos consistently opposed both Native American and African slavery. Unusually fervent Catholics led the way in opposing the mistreatment of the New World locals. While the Church couldn't stamp out slavery, it did mitigate it by promoting a code that limited abuses; slaves could take their owners to court for mistreatment and were allowed to earn money in their spare time in order to purchase their freedom. The Spanish allowed interracial marriage (except for governor types like our poor Don Francisco, who were indeed forbidden to marry locals); this practice blurred ethnic lines and helped to mitigate the racism that grew up in the British colonies. When the Spanish were cruel, it wasn't because they were urged on by hyper-zealous priests; it was because "practical and progressive" men didn't want to listen to those flaky do-good religious folks.

Now, when Sotolongo said that non-European members of the Spanish Empire were as dear to the king as the noblest don, I'm not 100 percent certain the monarch would have backed him up—but the priest was in the ballpark.

The Searles pirate raid did have all the marks of an inside job.

8) "Poker" (1683)—The Castillo was built because the Searles raid exposed the town's vulnerability. In the past, the town had relied upon a series of wooden forts, each of which rapidly fell into decay in Florida's climate and none of which did much to deter attackers. The new stone fort was intended to defend against both pirates and English encroachment from the north— the day of the buccaneers was coming to an end, but the day of direct conflict among the New World powers was just kicking off.

The fort was still under construction when the buccaneers attacked in 1683, and the events unfolded as in the story. Construction on the Castillo continued for decades after that, but it was at least minimally ready for combat by the time its next confrontation occurred.

9) "Twist of Fate" (1684)—Buccaneers, those nautical brigands who captured cities, never bothered St. Augustine again once the fort was built. But pirates, the seagoing crooks who captured ships, were the scourge of colonial America for several more decades. They were even less likely than their predecessors to worry about niceties such as nationality. When suspected pirates were captured north of town, just a year after the last buccaneer invasion, the governor was understandably concerned. But once Andrew Ranson was given the run of the city, he became a respectable citizen.

10) "The Christmas Siege of 1702" (1702)—The relevant conflict was called "Queen Anne's War" in the New World and the "War of Spanish Succession" in the Old. Just to add to the confusion, it can be considered the second in a series of French and Indian wars between France and England, although it started because a Spanish king died. European powers went to war to decide whether a pro-French or a pro-English monarch was going to take over the Spanish throne after Charles the Second's demise. The war was fought in Europe, up north around Quebec, on the western frontier of the English colonies—and on the Florida frontier. In the New World, the combatants involved Native Americans as well as Europeans. As mentioned in the story, it would probably be fair to describe the conflict as the First World War. Florida became involved because England declared war on both France and Spain.

St. Augustine's role in the war is described in the story; its fort rode out the contest even though the town was burned. But the impact of the war on La Florida as a whole was huge. The Spanish had an extensive network of missions across the Southeast, and Native Americans were very much citizens of the Spanish Empire—until this war, when Florida tribes such as the Timucuans were almost wiped out. This cleared the way for the settlement of Georgia by the English and made it easier for the Seminoles to move into the Florida peninsula.

The war was about who sat on a European throne and whose flag flew above New World lands. But perhaps the biggest issue at stake, from a long-term perspective, was whether Native Americans were to be citizens (even if second class) or nuisances with no rights to be removed as soon as possible. We know how that came out. One big reason was Queen Anne's War.

11) "The Remarkable Ear of Robert Jenkins" (1739–48)—OK, I'm going to zip right past the War of the Quadruple Alliance, the Blockade of Porto Bello and the Anglo-Spanish War. These were basically a continuation of Queen Anne's War and led into the war we're talking about now.

During these conflicts, the British won the right to sell slaves to Spanish colonies for thirty years, and the Spanish won the right to inspect British vessels to make sure the privilege wasn't abused with other cargoes. When the thirty years of the treaty ran out, the British didn't want their slave trading with Spanish colonies to end, and they didn't want Spaniards inspecting their ships. On a more local level, Governor Oglethorpe of Georgia was hoping for Florida conquest, partly because he wanted land and partly because St. Augustine was a refuge for escaped Georgia slaves. In short, there were a number of reasons why members of Parliament were so willing to be convinced by an ear made of rabbit skin.

Now the Spanish should not be confused with modern civil rights workers, but the status of blacks in the Spanish Empire was often far better than in the English colonies. As we've noted, the Catholic Church campaigned against slavery and succeeded in mitigating some of its worst abuses. In Florida, the governors adopted a policy of offering sanctuary and release from slavery for black fugitives from the English colonies who could make it to St. Augustine. When those escaped slaves reached St. Augustine, they looked for work. And many of them joined the army.

The city was saved during Oglethorpe's invasion because his troops were stopped north of town by a small outpost called Fort Mose—which was manned by escaped slaves. The same policy that helped motivate the British attack on St. Augustine gave the Spanish a winning edge.

The War of Jenkins' Ear eventually segued into the War of Austrian Succession. And let's not even talk about the Seven Years' War. Because that's another story.

12) "Lucky Pierre" (1742)—The story of the Southeast during the 1700s was one of English colonies pushing into Spanish territory; this tale tells of a last-ditch effort by Florida to push back. The invasion of Georgia was defeated at the Battle of Bloody Marsh. Still, the campaign could easily have had a different outcome, and if it had, the history of the United States would have been substantially altered. It is doubtful that the American colonies would have been so eager to declare independence if they had still been afraid of Spain on their southern border.

13) "Extreme Bird-Watching and the Fallibility of Risk-Management Specialists" (1774)—Britain eventually ended up with possession of Florida, but not through direct conquest. At the end of the French and Indian War, which somehow involved Spain, England captured Havana, Cuba. Spain

readily traded all of Florida to get Havana back—St. Augustine never did get much respect. Almost all of the Spanish, their Native American allies and the blacks who were in danger of being re-enslaved left for Cuba when the British took over. The lobster-backs were in charge for only twenty years before giving the place back to Spain at the end of the American War of Independence. But if the British period was brief, by St. Augustine standards, it nevertheless brought a lot of changes—economic development and the expansion of European settlements far beyond St. Augustine, but also widespread slavery.

William Bartram is neck and neck with de Soto in number of historical markers. His travels took place toward the end of the British period and overlapped with the War of Independence. He journeyed throughout the Southeast from 1773 to 1777 and, in 1791, published a very influential book about his observations of plants and animals. The quality of its writing helped to kick off the Romantic movement, inspiring writers like William Wordsworth and Samuel Coleridge. Bartram's writings also provide us with much of what we know about Florida's Native Americans.

Some have doubted the accuracy of Bartram's account of ferocious alligators stretching from shore to shore across a branch of the St. Johns River. These folks should shine a bright light across the surface of the St. Johns some dark night, count eyes and divide by two.

14) "Governor Quesada's Affliction" (1796)—This story occurred during the Second Spanish Period (hey, they brought back Classic Coke), after Spain recovered Florida from a discouraged Britain at the end of the American War of Independence. Many of the St. Augustinians who had moved to Cuba when the English took over returned at this time. But Florida never really prospered during the Second Coming of the Dons, because an impoverished Spain, trying to cope with an invasion by Napoleon, had even fewer resources to spare than during the first period.

As the story notes, the highest-ranking black officer to live in St. Augustine—one of the highest-ranking officers, period—was Jorge Biassou. He made his rep as one of the top rebel commanders during the struggle for Haitian independence. The rebels would have been satisfied to become ordinary French citizens; they offered to sign a peace treaty in exchange for the same human rights declared in the French Revolution. Napoleon, more preoccupied with conquering Europe than with what a bunch of slaves were doing, refused. Which proved to be a big mistake. The eventual loss of Haiti was one of the main reasons that Bonaparte was willing to sell the

Louisiana Purchase for such a bargain price. Biassou and his comrades in arms influenced U.S. history as well as Haitian.

He joined the Spanish army because Spain intervened on the rebels' behalf—more to bug France than because of any democratic ideals. An excellent general, he soon earned a promotion and honors. It is tempting to see the man as a heroic freedom fighter, but he never did fit easily into a single pigeonhole. That depiction is flawed by the fact that he owned slaves himself once he joined the Spanish. Also, when the Spanish ended up fighting against the Haitians, Biassou remained loyal to Spain and fought against his erstwhile allies like Toussaint L'Ouverture. Which is why he's not highly honored in Haiti.

But he was highly honored in Spain, with rank and prestigious medals. Honored, although not beloved. He was a black man who had fought successfully against whites, and he was the subject of dreadful rumors that, true or not, were believed. He was supposed to have killed white patients in a hospital; to have used strange and disgusting voodoo rituals to aid him in some of his battles; to have filled his war tent with kittens, snakes and human bones; to have performed strange rituals with naked women dancing around bonfires. And, of course, there was that charming Biassou personality to contend with. I suspect the head honchos in Cuba were scared of him.

All of which explains why he ended up in the backwater of St. Augustine, where his very presence as a black general created stress on the town's delicate racial balance. Still, as the story says, when he died the locals buried him with full honors. His former opponent, Governor White, helped to oversee those ceremonies.

The Second Spanish period turned out to be almost as brief as the British Period. The Americans pressed south, challenging the Spanish with freelance invasions and encouraging the Seminoles to harass Florida residents. Spain lacked the resources to defend the colony and eventually sold it to the United States in exchange for cancelling some debts. By 1821, St. Augustine belonged to America.

15) "Ralph Waldo Emerson, Martin Luther King Jr. and the Barking Methodists" (1827; 1964)—Once Florida was taken over by the United States in 1821, it almost immediately became a tourist destination. People from UpNorth came for the mild winters and the quaint old Spanish artifacts. Emerson came for his health, hoping to recover from an illness that afflicted him (probably tuberculosis, which killed his brother). As mentioned in the story, the visit probably had a lot to do with his later antislavery activities.

The Methodists were very much pro-black and antislavery initially. As noted, half of the first Methodist congregation in St. Augustine was black. Back in Britain, Methodists played a major role in the popular movement that led the country to first outlaw the slave trade (the British navy did a lot to stop that atrocity) and finally to abolish slavery in the British Empire—decades before the United States did the same. But as Methodists in the South became respectable, and part of the society around them, they backed off of their earlier position. Some Methodist preachers, who could barely feed themselves in Reverend Jerry's time, even became slaveholders. The northern Methodists eventually split from the southern Methodists over this issue, and the same thing happened to many other Protestant denominations.

Jumping ahead—the civil rights movement was reaching a climax in 1964, with the Civil Rights Bill coming up for a vote. St. Augustine's movement began in 1963 and met with fierce resistance from the Klan. Martin Luther King was invited in, and the subsequent events in St. Augustine are often given credit for helping to pass the Civil Rights Bill.

16 and 17) "A Dream of Pyramids" (1835–42); "Hogtown Changes Its Name"—The Seminole tribe was made up of people who had separated from other tribes such as the Creek; its members came to Florida from Alabama, Georgia and Mississippi. They were not one of the original Florida tribes such as the Timucua, although remnants of those original tribes may have eventually joined them. The name "Seminole" could have come from the Creek phrase "ishi semoli," literally meaning "the people the Sun God does not love" but implying a runaway, or the name could have come from the Spanish "cimarron," meaning a domesticated animal that has gone wild. In Florida, the tribe became a nation of cattle raisers. They were joined by escaped slaves, who became known as "the Black Seminoles," and this brought down the wrath of the Americans.

There were three Seminole Wars, also known as the Florida Wars. The first, roughly 1817–18, took place mainly in west Florida and involved Andrew Jackson invading to punish the Seminoles and recapture the escaped slaves who had joined them. The Second Seminole War, 1835–42, was fought because the tribe resisted being moved from the East to lands in the West. It lasted longer than any other Indian war, longer in fact than most American wars, and it is the one our two stories are set in. The Third Seminole War, 1855–58, was triggered when whites stole supplies from the tribe; it was fought mostly in south Florida.

St. Augustine served as a center of the war against the Seminoles. Nearby plantations were burned, and soldiers were stationed here. As mentioned in one of the stories, the victims of the Dade Massacre were buried here. One of the most famous Seminole leaders, Osceola, was captured just south of the town when a United States officer violated a truce. The officer was criticized for breaking his word, but the chief was not released.

Osceola and some other Seminoles were held in the Castillo de San Marcos, by then called Fort Marion. Two of the imprisoned men managed to climb to a high window and squeeze through the opening, but Osceola was too sick to follow. He later was sent to South Carolina, where he died in captivity.

While many Seminoles were shipped out West during the various conflicts, some always remained in Florida; they never signed a peace treaty with the United States.

There is some fiction in the story, though. The specific enlisted men named in the tale are literary creations, and as far as I know, no one actually dreamed about pyramids during Dade's march to destiny.

18 and 19) "Gotta Get a Receipt"; "The Year Without Tourists" (1861–65)—St. Augustine was not a central theater during the War of Northern Aggression, aka the Civil War, but it was involved. It sent Confederate soldiers to fight in other theaters; it was occupied for one year by the South and then for the rest of the war by Union troops. The town's Fort Marion, previously known as the Castillo de San Marcos, had been made obsolete before the war began by rifled artillery and exploding shells; armies were just beginning to learn that a hole in the ground offered better protection than thick stone walls. No serious effort was made to defend the fort or the town. The townspeople of St. Augustine were divided in their sympathies, with many citizens having been raised in the North; there was a Yankee invasion long before the gunboats showed up in 1862.

But Confederates remained active all around St. Augustine, and cavalry operated up to the city limits throughout the conflict. The area west of the St. Johns River was known as "Dixieland" because it was controlled by J.J. "War Eagle" Dickison, an audacious Southern raider who routinely took on superior forces and who captured the Union gunboat *Columbine*. The area supplied cattle to feed the Confederate army.

The fact that some of the St. Augustine Blues were blacks is interesting and points out a missed opportunity for the Confederacy. Many free blacks throughout the South wanted to fight for the Southern cause, for the same reason that Robert E. Lee threw his lot in with the Confederacy although

he owned no slaves—the South was their native land. In most places, those blacks were denied the chance to show their patriotism. Toward the end of the war, as the lack of Southern manpower tipped the scales increasingly toward the North, Confederate general Cleburne proposed turning the tide by freeing those slaves who would fight for the South. He was ignored, and the Confederacy missed its best chance to achieve independence. The Southern government did eventually allow free blacks to join the army, but by then it was too little, too late. Prejudice had trumped the desire for independence.

20–26) "John, Roseda and Polly: A Cracker Family"; "The Picture"; "Truck Farmer"; "This Little Light of Mine: Mattress Man in the Signal Corps"; "Uncle Brother"; "Waiting for Jingle Bells"; "The Ferocious Fleas of Marjorie Kinnan Rawlings" (1900–60)—This series of stories provides a look at cracker Florida, especially the poor parts of the state. Originally, the term "cracker" referred to poor whites of Scots-Irish descent who mostly lived in rural areas. More recently, it has been used to refer to those born in Florida—all 138 of us. I personally think that anyone who spends summers in the state qualifies for that esteemed title. Crackers (in the original sense) and their descendants make up a lot of the St. Augustine population, and the attitudes of the town have long been influenced by the cracker culture of the surrounding countryside (which some people call "Baja Georgia").

You can argue that—as in the story of John, Roseda and Polly—the 1800s lasted until the 1950s in much of rural Florida. A lot of places didn't have electricity or indoor plumbing, and many roads were dirt. It was often a pioneer culture, with people doing for themselves or doing without—clearing land, plowing with mules and even oxen, running their own sawmills, making their own tools in their own blacksmith shops, producing their own shingles, building their own houses. The Great Depression made the isolation worse, and it was World War II that opened up interior Florida to the world. This period was marked by poverty and prejudice, but also by people trying to overcome both.

At this point we move away from the history books to family history—my family history. Sure, that's self-centered, but it's a lot easier to research—and it may give some insight into a different time and culture.

27) "Jamestown and the Ancient City" (1965–2007)—A lot of St. Augustinians were impressed with Jamestown's 400th anniversary, and many were inspired to make big plans for our 450th. If this book doesn't reach you too late, come on down—or up, as the case may be. This place is worth a visit anytime, but should really crank up as the birthday approaches.

28) "When Crackers Met Spaniards: Bloody Marsh Reenactment" (2006)—
St. Augustine has celebrated its past at least since the American takeover in
1821 and exploited that past to bring in tourists. Interest has continued to
grow in the modern era, and a number of dedicated volunteers try to bring
that past alive by reenacting. Visitors to St. Augustine can almost always see
"Spanish" or "British" soldiers firing cannons, setting up military camps or
fending off "pirates." The town re-creates a number of historical episodes,
such as Menendez's landing, Drake's raid and the Searles pirate attack.
Artisans demonstrate the crafts of former days. Reenactors are a major part
of the modern town.

One of the more interesting events the reenactors stage takes place outside of
St. Augustine, around the reconstructed Fort King George in Darien, Georgia.
Spanish "soldiers" come up from St. Augustine to meet British "troops" and
replay an ancient battle. Civilians dressed in period costume perform the
typical chores of another time. The rest of us get to time travel a little.

\mathcal{S}UGGESTED \mathcal{R}EADINGS

For a quick overview of St. Augustine's history, a very good resource is *Oldest City: St. Augustine Saga of Survival* (Jean Parker Waterbury, ed., St. Augustine Historical Society, 1983). It's still easy to find in bookstores and libraries. A useful and entertaining source of both history and stories is Gene Burnett's series of books—*Florida's Past: People and Events That Shaped the State* (Sarasota, FL: Pineapple Press, 1988). Still another good resource for storytellers, if they can locate a copy, is an older book—*The St. Johns: A Parade of Diversities* (Branch Cabell and A.J. Hanna, New York: Farrar & Rinehart, Inc., 1943).

Readers interested in more depth on any of the topics in this book should start with the St. Augustine Historical Society's journal *El Escribano*, where they will find scholarly but readable articles on practically every aspect of the city's past. Of particular interest are the issues on "Defenses and Defenders of St. Augustine" (vol. 36, 1999); "Firestorm and Ashes: The Siege of 1702" (vol. 39, 2002); "St. Augustine's British Years: 1763–1784" (vol. 38, 2001); and "Civil War Times in St. Augustine" (vol. 23, 1986).

Serious (well, interested—you don't have to be all that serious) readers should visit the historical society's library, either in person at 271 Charlotte Street, St. Augustine, Florida 32084 (where you will find very helpful and efficient volunteers, along with a wealth of information), or online: sahs.pastperfect-online.com/36220cgi/mweb.exe?request=advform.

Below is a list of other books that readers may find helpful and that served as sources for the present volume.

Arnade, Charles W. *The Siege of St. Augustine in 1702*. Gainesville: University of Florida Press, 1959.

Campbell, Richard L. *Historical Sketches of Colonial Florida*. 1892. Reprint, with introduction by Pat Dodson. Gainesville: University of Florida Press, 1978.

Committee of the General Assembly in South Carolina. *An Impartial Account of the Late Expedition Against St. Augustine Under General Oglethorpe*. 1742. Reprint, with a preface by Samuel Proctor, general editor. Gainesville: University of Florida Press, 1978.

Conner, Judson J. *Muskets, Knives and Bloody Marshes: The Fight for Colonial Georgia*. St. Simons Island, GA: Saltmarsh Press, Inc., 2001.

de la Vega, Garcilaso. *The Florida of the Inca*. Translated by John and Jeanette Varner. 1605. Reprint, with introduction by John and Jeanette Varner. Austin: University of Texas Press, 1996.

Fairbanks, George R. *The History and Antiquities of the City of St. Augustine, Florida*. 1858. Reprint, Gainesville: University of Florida Press, 1975.

Fretwell, Jaqueline K., and Susan R. Parker, eds. *Clash Between Cultures: Spanish East Florida, 1784–1821*. St. Augustine, FL: St. Augustine Historical Society, 1988.

Gannon, Michael V. *The Cross in the Sand: The Early Catholic Church in Florida*. Gainesville: University of Florida Press, 1965.

Johns, John E. *Florida during the Civil War*. Gainesville: University of Florida Press, 1963.

Lyon, Eugene. *The Enterprise of Florida: Pedro Menendez and Spanish Conquest of 1565–1568*. Gainesville: University of Florida Press, 1976.

Mauncy, Albert. *Menendez: Pedro Menendez de Aviles, Captain General of the Ocean Sea*. Sarasota, FL: Pineapple Press, Inc., 1992.

Missall, John, and Mary Lou Missall. *The Seminole Wars: America's Longest Indian Conflict*. Gainesville: University of Florida Press, 2004.

Sewell, R.K. *Sketches of St. Augustine*. 1848. Reprint, with introduction by Thomas Graham and general editor's preface by Samuel Proctor, Gainesville: University of Florida Press, 1976.

Tanner, Helen Hornbeck. *Zepedes in East Florida*. Jacksonville: University of North Florida Press, 1963.

Wynne, Lewis N., and Robert Taylor. *Florida in the Civil War*. Charleston, SC: Arcadia Publishing, 2002.

About the Author

D rew Sappington has worked a variety of odd jobs—at least they seemed odd to him. These include college professor, pest control guy, ward administrator in a mental hospital, researcher, bouncer at a teenage nightclub, fencer (hog-wire, not swords) and clinical psychologist. A member of the Tale Tellers of St. Augustine, he performs in theaters, at folk festivals and most anywhere people will sit still. He has published one textbook, forty articles in professional journals (including *Psychological Bulletin* and *American Psychologist*) and a few stories in publications that people actually read. He enjoys history and St. Augustine.

Visit us at
www.historypress.net